CHOOSE ME

CHOOSE ME
PORTRAITS OF A PRESIDENTIAL RACE

PHOTOGRAPHS BY
ARTHUR GRACE

FOREWORD BY SAM DONALDSON

TEXT BY JIM WOOTEN

AFTERWORD BY JANE LIVINGSTON

A NEWSWEEK BOOK

DISTRIBUTED FOR BRANDEIS UNIVERSITY PRESS
BY UNIVERSITY PRESS OF NEW ENGLAND
HANOVER AND LONDON

University Press of New England:

Brandeis University
Brown University
Clark University
University of Connecticut
Dartmouth College
University of New Hampshire
University of Rhode Island
Tufts University
University of Vermont

Copyright © 1989 by Arthur Grace
Photographs © 1987, 1988 by Newsweek, Inc.
All rights reserved. Photographs used by permission
of Newsweek, Inc.

Library of Congress Cataloging-in-Publication Data
Grace, Arthur.
 Choose me.
 (A Newsweek book)
 1. Presidential candidates—United States—Portraits.
2. Presidents—United States—Election—1988. 3. Presi-
dents—United States—Election—1988—Pictorial works.
4. United States—Politics and government—1981–1989.
5. United States—Politics and government—1981–1989—
Pictorial works. 6. Photography, Journalistic—United
States. I. Wooten, Jim. II. Title.
E840.6.G7 1989 973.927′092′2 89–5643
ISBN 0–87451–491–6
ISBN 0–87451–492–4 (pbk.)

Designed by Pam Castaldi
Text edited by Roberta Pliner
Photographs edited by Karen Mullarkey

∞

Printed and bound in Japan

To my wife, Florence, who makes all things possible…and to those driven souls who run for President and all those crazy enough to go along for the ride.

There are many people who deserve my gratitude and affection for their unstinting support and assistance in producing this book.

First, I thank *Newsweek* picture editor Karen Mullarkey. Without her vision, guidance, and commitment, this project would never have been possible. I will always be grateful.

Special thanks also to my literary agent, Carol Judy Leslie, who worked long and hard to see *Choose Me* become a reality and along the way became a valued friend.

I also thank:

ᔰ my parents, Sonia and Milton Pliner; my sister, Dianne Solomon; and my brother, Nathan Grace, for their encouragement, support, and belief in my work over the years;

ᔰ Pam Castaldi, art director of *Choose Me*, for her elegant design work and her remarkable capacity for putting up with me;

ᔰ Sam Donaldson, Jim Wooten, and Jane Livingston for their superb written contributions that have made *Choose Me* a much richer book in quality and insight;

ᔰ *Newsweek* editor-in-chief Rick Smith and executive editor Steve Smith for their constant support in the pursuit of these photographs and their publication in *Newsweek;*

ᔰ Tony Fuller, *Newsweek* senior editor, for his concept of doing a different kind of campaign portraiture;

ᔰ Patricia Bradbury, Peter Goldman, Guy Cooper, and Kenneth Auchincloss for their support and enthusiasm for these photographs, many of which appeared in the *Newsweek* election special issue;

ᔰ Bill Pierce, for his friendship, constructive criticism, inspired teaching, and enthusiastic encouragement of my work;

ᔰ Eliane Laffont, director of Sygma, U.S.A., for seventeen years of friendship, loyalty and career guidance.

ᔰ Michael Evans, for his valued advice and selfless efforts on behalf of this project;

ᔰ Dr. John R. Hose of Brandeis University Press, who discovered *Choose Me* and had the vision to see its potential;

ᔰ Asman Custom Photo Service of Washington, D.C., and especially master printer Kelly Reynolds for his first class printing of these photographs;

ᔰ Ralph Alswang, Eddie Clift, and Michelle Litvin for their tireless assistance on the book;

ᔰ my sister, Roberta Pliner, for her fast, competent text editing.

CONTENTS

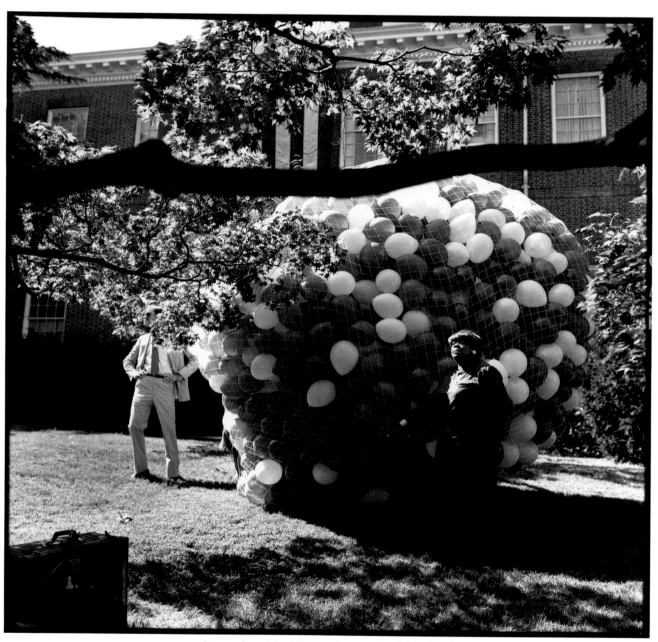

September 14, 1988 Annapolis, Maryland

FOREWORD

by SAM DONALDSON
ABC News Correspondent

In the presidential campaign of 1988, I covered Michael Dukakis for ABC News. Hold on! Before you start yawning, I assure you I am not going to talk about the issues, now dead and buried, but about the pictures, still vivid. That is what this album is about, pictures.

Over the years, politicians have refined their approach to the visual medium. There was a time when photographers photographed events that occurred naturally. There is John F. Kennedy leaning on his desk in lonely repose, silhouetted against the fading light. There is Lyndon Johnson pulling up his shirt to proudly display his fresh abdominal scar. There is Richard Nixon at the helicopter door, crooking his arm in a twisted farewell to his presidency. And there is Ronald Reagan, sticking out his tongue and wagging his fingers at photographers.

Those pictures are powerful. But it's getting harder and harder for all of us who cover politicians to get hold of the "real McCoy." Political campaigns are now carefully staged for the picture media. They are scripted, choreographed, sanitized. Access to reality has been severely limited. Today the politicians still want the cameras to project their messages but they want it done on their terms and almost never in a natural, spontaneous way.

There was a time when we all went along on campaigns and politicians did what they wanted to do…they played to crowds and we took pictures of them playing to crowds. We watched events as they unfolded. Now, instead of just talking to people, the only time they talk to people is so they can be photographed talking to people. They simply use the medium for its own sake…take my picture looking strong, take my picture looking wise, use an opponent's picture that he may have unwisely given us to depict him as weak.

Dukakis was not very good at constructing the perfect photo opportunity. That may have contributed to his loss. Consider the famous "tank" picture. Having been accused by his opponent George Bush of being soft on defense, Dukakis rode in a tank in an attempt to send the visual message of toughness. I'll never forget the day. That tank was huge, menacing, scary. Anyone would have looked small sitting with his head sticking out of the turret. A good advance man, schooled in the art of the "photo opportunity," would have seen that and discarded the idea. But the Dukakis handlers did not. Unwisely, he donned a helmet and roared down the field towards the press. As the tank swept by, I yelled at Dukakis and he grinned and wagged his finger at me. He was cooked. That was the shot we all used on the evening news. Moreover, that was the shot George Bush's media masters used in their commercials making fun of Dukakis. Such media events have little to do with a candidate's actual position on anything but have everything to do with their attempt to mold public opinion.

That's why what we have in this book is so valuable. Arthur Grace, *Newsweek*'s veteran political photographer, has moved around the roped-off media pens where we are all made to stand and gotten inside the campaign of 1988. He's done it through enterprise, hard work, and an eye for an interesting picture. He's done it also by earning the trust of the candidates. Often, as these pictures demonstrate, the candidates let him in. Men whose public faces are all energy and smiles have let him see them as they sit exhausted and dejected. Candidates who want to be pictured as in command have let him see them at moments of uncertainty. In short, in this age of media staging, Grace has managed to give us a fascinating glimpse of reality. ❧

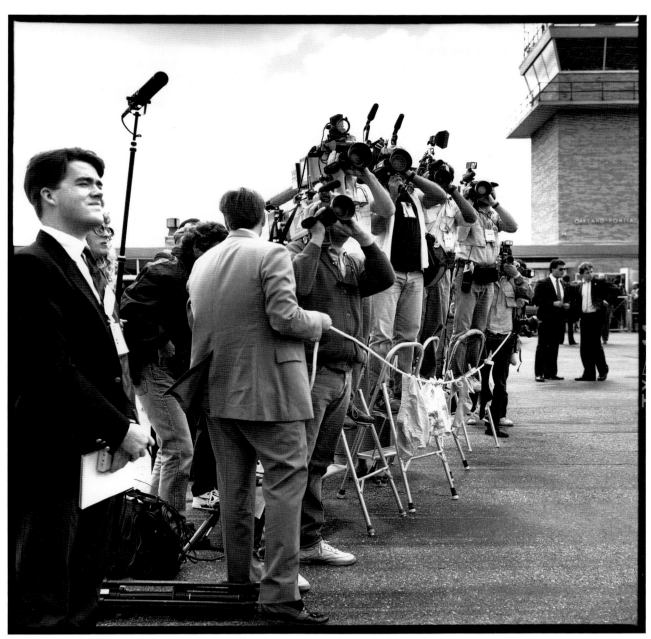

September 13, 1988 Waterford, Michigan

ONE CAMPAIGN TOO MANY

by JIM WOOTEN
ABC News Correspondent

*In human relations, kindness and lies are worth
a thousand truths.*

—Graham Greene, *The Heart of the Matter*

One winter's afternoon in Washington, I happened to run into a tall, lean, nicely dressed fellow who seemed to be just about the happiest man in America. He was positively ebullient, the very picture of self-assurance and well-being, the perfect personification of exuberance and exhilaration.

And why not?

After all, only a few moments before, in a fast flicker of Constitutional magic, he had been transformed into the 41st President of the United States. In the quick recitation of a simple, yet historic oath—a mere 35 words—with his hand resting on the Bible used by George Washington two centuries before, he had realized at long last the golden fulfillment of a shining dream that had driven his life for nearly as long as he could remember. When the ceremonies ended, with cannons booming and belching smoke, with massed brass bands blaring martial music, George Herbert Walker Bush came bounding up the steps of the Capitol wearing the beatific countenance of a golfer after a hole-in-one.

I was waiting for him at the top of the stairs, just inside the Rotunda.

"Congratulations, Mister President," I said, showing him the microphone. "Want to stop and talk?"

"Just did, Jim," he laughed, without breaking stride. "Weren't you listening?"

"Long way from Oshkosh," I suggested, falling into step, not at all certain he'd remember—but he did or pretended to, at least.

"Much longer than that," he chuckled.

"Worth the trip?", I wondered, running out of cord.

"Oh, you bet," he said over his shoulder. "In spades, Jim. How 'bout you?"

Before I could respond, he was gone, swept swiftly along on the flood-tide of his entourage, out the great bronze doors and into history, a sprightly bounce in his step, as pleased with himself as a child with a brand-new toy. For a fleeting millisecond, standing there on that grand expanse of marble far beneath the Capitol's soaring dome, I felt myself drawn into the warmth of his boyish enthusiasm. It seemed unavoidably contagious.

And why not?

After all, merely at the behest of the American people, the American presidency had once again changed hands. I had witnessed several such moments and never tired of them. It was a transfer of such prodigious power, and yet it had always been accomplished with neither crisis nor chaos. There had been no coup d'état, no rioting in the streets, no revolution or civil war, no braided generals with blood on their hands preening in the background. Instead, on that crisp Friday afternoon in January, there had been only that simple little ritual, painless and public and old-shoe familiar. Nothing more, nothing less, and it was done. In his inaugural address, the new President had deftly described it as democracy's big day. Who could argue with that? George Herbert Walker Bush was absolutely right. He was standing at the epicenter of one more American miracle.

Who would be so cynical as to contest the magnanimous tone of the new President's remarks that day, the soft-spoken speech that fell pleasantly on the ear, made even more pleasant by its context and its physical setting. The marvelous sprawl of the West Front

of the Capitol, centerpiece of an enduring idea (he had called it democracy's front porch, a folksy evocation of the country as community), looked out on Independence Mall, a long and lovely westward vista, with the Washington Monument needling its way into the winter sky and, just beyond, the Lincoln Memorial, sitting in stately elegance at the edge of the Potomac. Richly draped bunting hung from every portal; hundreds of flags flapped and snapped in the wind as the new President spoke of a new breeze blowing through the land. His speech, for the most part, was remarkably free of the high-blown rhetoric that commonly spoils such occasions. He earnestly called for the best of the country he would lead. In an era of conspicuously obscene consumption, he reminded his fellow citizens (he had called them neighbors, a nice touch) that the deeper successes are made not of gold and silk but of better hearts and finer minds. He had urged a new tolerance of ideas across the land, a new acceptance of diversity, a new kindness in politics, a new gentleness in policy. He promised to heal social wounds and put an end to a generation of divisiveness. There would be harmony and conciliation, he said, and, although most of his words had been written for him, their impact was no less moving, never more so than in his conclusion:

"Some see leadership as high drama and the sound of trumpets calling—and sometimes it is that; but I see history as a book with many pages, and each day we fill a page with acts of hopefulness and meaning.

"The new breeze blows, a page turns, the story unfolds; and so, today, a chapter begins—a small and stately story of unity, diversity, and generosity, shared and written together."

There was no doubt about it. It didn't matter to me—and I'm fairly sure it was of no consequence to the 200,000 who gathered there at the Capitol or the millions more in the television audience—whether he spoke his own words or someone else's. What mattered was that the new President was describing exactly the way America ought to work, precisely the way America was meant to be.

And who could possibly take issue with that?

Nevertheless....

While he was outside on the East Front (democracy's back porch, perhaps?) bidding farewell to his predecessor, I was struck by the stark contrast between the inauguration of the President, with its noble overtones, and the campaign for the presidency, with its churlish undertones. One had been...well, undeniably nice. The other had been...well, downright nasty. It was as though each were totally unrelated, completely unconnected to the other. They were the products of the same society—this nice inauguration and the nasty campaign that had preceded and produced it—but which was its more accurate reflection? Was it possible to discern anything significant about the country from either this presidential inauguration or the presidential campaign leading to it?

As usual, I had been caught in the swirl of the pomp and pageantry of the day but, quite unexpectedly, I'd also been captivated by the new President's words. Yet when those moments had passed, as they quickly did, I was fairly certain that I had detected the distinct odor of hypocrisy. Perhaps it was in my nostrils alone, some curious olfactory mirage, but it was there nonetheless. In the solemn celebration of the end—the inauguration, there had been the silken justification of the means–the campaign.

It didn't exactly make it democracy's big day on my calendar; but then, I hadn't noticed many such days in the previous eighteen months.

Towards the end of it, nearly exhausted and slightly bitter, flying across the country one last time, I remembered how different I'd felt in the days before the campaign had actually begun, how impatient I'd been to get started again, how eagerly I was counting the days until the flag dropped—and just how hard I'd tried not to show it.

"Just another assignment," I'd shrug. "Nothing special."

Schneiders, an honest broker, wasn't buying. "You love it," he said one day. "Why the hell not admit it?"

He was right, of course. I did love it and always had, right from the first moments of my first campaign assignment in 1968; but I

couldn't admit my affection, couldn't actually own up to it, not to him or anyone else. To have done so would have been nothing less than a public recantation of the good gray work ethic so deeply rooted in my soul, a credo familiar to millions of Americans like me who were born into families well acquainted with the Depression: those activities from which one derives pleasure do not constitute and cannot rightly be defined as genu-

> He had just been told that Reagan had decided to name Gerald Ford as his running mate. "That's it," said Bush, clearly shaken. "I'm getting out of politics."

ine work. Therefore, the years and the miles I had invested in journalism, and especially to reporting on presidential campaigns, did not qualify as honest toil, as decent labor, not if I confessed to having actually enjoyed them.

In my occasional lectures and speeches, I often describe journalism, especially political journalism, as the last refuge of the adolescent. It has always provided me and others like me with the opportunity to participate in reasonably serious enterprises without the painful obligation of being unreasonably serious about ourselves. Now, it is not my intention to suggest that those who have regularly covered the presidential campaigns are immature, although it cannot be denied that a few of us have behaved that way from time to time. What I do mean to suggest is that the wonderful essence of adolescence—its untrammeled free spirit—was always compatible with the context of a presidential campaign. Because it was, most who have ever done it once have ultimately done it again…and again…and again.

Schneiders had it right. Many of us were probably compulsive about it, would probably have paid for the assignment ourselves, instead of the other way around.

Not even the grind of travel could deter us. In fact, I always relished it and seldom complained, except when I wanted to persuade someone (my wife, for example) that a campaign was hard work. The reality is that I always looked forward to every mile, to the chance to see the country, including places I've seen before and places I've never been and, without a campaign to take me there, would probably never be.

So it follows that I could be easily attracted to anything that demands wholesale travel, which is precisely what a presidential campaign demands. Covering Spiro Agnew's frequent retreats to Palm Springs, California, I watched dozens of desert sunrises, sunrises I would never have seen had I chosen to become a banker or a doctor or a lawyer. Over the course of the years, watching the New Hampshire primaries punish and reward the winners and losers, I also watched the New England winters quietly transform the countryside into lovely Currier & Ives postcards. I've seen the White Mountains of New Hampshire magically disappear in quick, dense fog, and, when the campaign moved west, watched the Rockies gently turn purple from 30,000 feet and walked through vast fields of corn in Iowa, oceans of wheat in Nebraska, and thick forests of giant trees in Oregon and Washington. I never grew weary of the travel, not once. It was my education, and I always wanted more (especially since my employers were paying the tuition).

Nor could I get enough of the camaraderie a campaign always offered—the friendship and fellowship of like-minded companions and colleagues, my crafty co-conspirators in a high-minded plot to live forever and never grow old. We shared the same sweet secret, and while the membership might change, the fraternity remained constant. I've met some of my best pals out on the trail—the irrepressible Sam Donaldson of ABC News, for example, and Arthur Grace, of course, one of the great photojournalists, and many others whose friendships I'll always treasure—good folks I never would have known had I chosen to travel some other road.

The most compelling attraction of campaign journalism was always the opportunity to participate in little bits of history, the odds-on gamble that every so often, I could stand at the edge of some memorable moment. I did not always admire the candi-

dates—some were kind and decent men; others were genuine scoundrels—but I was pleased to know them within the context of their pursuits, to follow them as they scampered about the country asking America to choose them.

During two campaigns, I watched—and I must confess now that I rather enjoyed it every time—George Wallace turn ghostly pale each time his plane encountered the slightest turbulence. He didn't like me, and I didn't care for him—but I wouldn't have missed his combative campaigns for anything.

One evening in 1968, I'd nearly fallen asleep listening to Vice President Hubert Humphrey tell one tale after another from his early days in politics while he steadily became intoxicated on one Old Fashioned after another. I never met anybody else who preferred that cocktail.

In 1972, I heard George McGovern tell a small gathering of his supporters in South Carolina that "begging was better than bombing" the North Vietnamese, not one of his shrewder public observations, of course.

Later that same year, I was surprised along with everyone else one night when Spiro Agnew, facing his usual interruptions from hecklers in the crowd at a campaign rally in Montana, had pulled out a police whistle and blown it at the group, mainly kids. It worked beautifully. They shut up. It worked beautifully again the next day, in Wyoming, but on the third day, in Idaho, his strategy broke down. The kids brought police whistles, too!

In 1975, I sat in a crummy hotel suite in Johnstown, Pennsylvania, late into the evening, smoking cigars and sipping whiskey with Senator Walter Mondale, finally coming to understand that what he was saying without really saying it was that he didn't really want to run for President, not anytime soon, at least, that he wasn't prepared to invest himself to the extent that a campaign would require.

In 1976, I was exhilarated about catching Jimmy Carter in one of his clever verbal constructions designed to attract support from opposing sides of the same issue. That pleasure was greatly enhanced by his confession that, yes, that was exactly what he had done and his promise not to do it again. That same year, I enjoyed watching him try to tape a television commercial in Massachusetts, near the Concord Bridge and the Minuteman Statue, up to his knees in snow, his lips turning blue from the freezing wind, his teeth chattering, his entire body trembling in the cold. But he was determined to get it right and he did—eventually.

In 1979, I spent a few days with George Bush, at the beginning of his presidential pursuit, traveling around Wisconsin, visiting VFW clubs and church bazaars and wherever else there might be a few people guaranteed. We ended up in Oshkosh, and when we went jogging that night, we got lost!

I was there that night early in 1980 when Bush had gone to Keene, New Hampshire to debate Ronald Reagan and sat in slack-jawed amazement as the Gipper stole the show and perhaps the Republican nomination with his famous retort, "I paid for this microphone."

At a hotel bar somewhere in the spring of that year, I listened to James Baker explain that Bush just wasn't going to win the nomination and that, as his campaign manager, all he was trying to do was "keep the guy from getting run over" by the Reagan-train.

At the Republican convention in Detroit that summer, I ran into Bush backstage, looking as morose as I'd ever seen any politician look. He had just been told that Reagan had decided to name Gerald Ford as his running-mate. "That's it," said Bush, clearly shaken. "I'm getting out of politics." Later that night, Reagan changed his mind, and so, of course, did Bush, but I've never forgotten the sadness in his eyes or the bitterness in his voice.

Now, it isn't that any of these moments were so historically significant in themselves; in fact, in the larger reach and longer run of history, none of them was very important at all. But as part of the experience of reporting on campaigns, they help to explain why political journalism is not only an honorable pursuit but a fortuitous calling, mainly because it is so much fun!

Besides, over the years, you not only get to know some of the people who just happen to become President of the United States, you can also persuade yourself that you are in-

volved in relatively useful work. Every so often at the end of the campaign day, you can say with some logical justification that maybe, just maybe, you've given something back to the republic.

No wonder then, standing at the edge of the 1988 campaign, I was so eagerly impatient to get started again. Even after five campaigns, even after becoming a grandfather, I was still enjoying my adolescence. I still relished the opportunity to once again brush elbows with a little bit of history, see how the country changed since the last time, see my old pals and make new friends. I still looked forward to watching those White Mountains vanish in the mist and the Rockies turn purple once again; I still anticipated a little more fun and games.

It didn't turn out that way.

From a distance, 1988 seemed to be a watershed election, a singularly significant moment in our political history, to be remembered for years to come as a point of departure. By virtue of the 22nd Amendment limiting Presidents to two terms, there would be no incumbent in the race. The last time that obtained was 1968, when Lyndon Johnson declined to seek re-election, and Hubert Humphrey sought to succeed him. Like every other incumbent Vice President since 1836, Humphrey had subsequently bitten the dust...after a few Old Fashioneds, of course. The absence of an incumbent would be important, I figured.

The Democrats were in their usual state of transition, having decided to present a moving target. Change was their normal organizational mode, and the success of Ronald Reagan in the two previous elections seemed to mandate ever greater adjustments.

But the Republicans, without Reagan, faced an even more interesting decision: to present an alternative similar to the Gipper or simply an alternative.

At any rate, for both parties and for all those politicians who would involve themselves in the 1988 race, either as candidates or managers, the retirement of Ronald Reagan was no small matter. Most of them—and I think most of us in the media—agreed that

if Reagan had been given the Constitutional freedom to seek a third term—and had decided to do so—he would have won it, probably in another massive landslide similar to those he had scored in 1980 over Carter and in 1984 over Mondale. Such was the force of his personality and presence in American politics throughout most of the decade, but that force would be missing in the campaign of 1988. In its place would be simply the legacy of his eight years in office, the policies without the personality and the presence. That was something else, indeed.

The former Speaker of the House of Representatives Thomas P. "Tip" O'Neill, once showed me a cartoon he carried for several months in his wallet. Its theme was a polltaker calling on an average citizen. In the first panel, the man of the house is asked what he thinks of Reagan's domestic policies. His answer is furiously obscene, spelled out in asterisks, ampersands, dollar signs, and other symbols rather than words. In the second panel, he is asked his view of Reagan's defense policies. Once again, his answer is angry, unprintable, as is his answer to the next question on foreign policy. But in the fourth panel, when he is asked what he thinks of Reagan personally, he says, "Oh, he's a hell of a nice guy."

That, said O'Neill, is the Democratic dilemma.

But the 1988 campaign, while surely a referendum on the Reagan years and the Reagan policies, especially the massive deficits generated in the Federal budgets (more than all the preceding presidencies combined), would proceed without the famous Reagan charisma. That would make it a much more intelligent campaign of issues and ideas, instead of the mere contest of personalities to which we had become accustomed.

Or so I thought.

In the place of Reagan's presence, rushing to fill that rather sizable vacuum, the largest field of candidates in years and years was gathering. Including those who at one time or another announced they were considering presenting themselves as candidates but then eventually decided against it, there would be more than twenty men and at least three women on the prospective political charts

from early 1986 on into 1988. As I studied those long lists, trying to come to grips with what the campaign might eventually become before it actually began, I assumed that the very size of the field would make the enterprise significantly different from others I'd seen and therefore a potentially more fascinating piece of history to watch. The number of candidates would increase the number of ideas and issues. The possibility of an intelligent campaign, both in the primary season and on through the nominations and general election, seemed to me to be enhanced by the crowded lists, which early on appeared to include almost everybody who had spoken publically on politics or the economy in the previous eight years.

The more the better, or so I thought.

As it turned out, the crowd quickly dwindled. Jeanne Kirkpatrick, who'd left the Democrats in 1980 to work for Reagan's election and had quickly become a favorite of the Republican right-wing, decided her popularity was not sufficient to justify a candidacy. Patrick Buchanan was urged to take up her banner. He thought about it a while, then declined. So did Howard Baker. Lamar Alexander, the former governor of Tennessee, also said no to the Republican race after first saying maybe, as did former Secretary of Defense Donald Rumsfeld, explaining that he simply did not believe he'd be able to raise sufficient funds to wage a reasonably healthy campaign. Also from Illinois, Governor James Thompson considered it and then bailed out. Paul Laxalt, the former Utah senator and one of President Reagan's closest friends, was serious enough to form an exploratory committee, but after finding a dearth of available funds, he also declined.

There was a similar reduction in the Democratic ranks. Senator Dale Bumpers of Arkansas was encouraged to give it a shot by a gathering of well-heeled backers and several of his Congressional colleagues, including Senator Paul Simon. Eventually, Bumpers said no, as did Southern hawk Senator Sam Nunn of Georgia and, from Virginia, the former governor and future senator, Charles Robb, son-in-law of the late President Johnson. Geraldine Ferraro, who had served as Mondale's vice presidential candidate in the 1984 Democratic debacle, mulled it over for a while before saying no thanks; Representative Patricia Schroeder of Colorado spent two months trying to drum up support for her candidacy but eventually decided that it just wasn't there on her terms.

Even Lee Iacocca, à la General Eisenhower, was the target of draft committees

The Democrats were in their usual state of transition, having decided to present a moving target. Change was their normal organizational mode.

from both parties. The chairman of Chrysler, and one of the world's best selling authors for the previous couple of years, made several speeches about policies he'd change and programs he might endorse, managed to attract considerable attention by never actually saying no, but finally declined.

But perhaps the most fascinating of all the Democrats was Mario Cuomo, the governor of New York, who had come to national attention with his rousing keynote address to the 1984 Democratic Convention in San Francisco. There seemed to be little doubt among his friends and close aides that he wanted to run—in fact, some of them were traveling about the country suggesting both in public and private that he had already decided to do so—but the governor had consistently declared his disinterest, claiming as his basic reason the necessity to run the state of New York and the impossibility of doing so while simultaneously seeking the Democratic presidential nomination. Even so, the more he demurred, the more the press and some members of the party's hierarchy insisted that eventually Cuomo would jump in. Despite his flat statement on the eve of Valentine's Day, 1987 that he would not be a candidate at all, under any circumstances, very few in the media believed him.

(I did. Although I didn't know him all that well, he had always struck me as a fairly grown-up politician who did not require a

constant intravenous feeding of his ego. Not that he didn't have one. He did and it was sizable, but my sense of him was that his view of himself was already complete and did not need enlarging. Moreover, he did not strike me as the sort of man who would especially love slogging through the pig-pens and auction barns and bowling alleys and frozen corn fields of Iowa or the mud and mire of New Hampshire in pursuit of anything. If there had been some other equally viable avenue to the nomination, it might have been a different story.)

Still, even after the preliminary winnowing, the 1988 campaign would begin with a densely populated field. At one time or another, fourteen men would invest themselves, the loyalty of others, and a considerable bundle of cash in the active pursuit of their party's nomination.

Understandably, a wide variety of ideology was readily available, from the Reverend Jesse Jackson on the left to the Reverend Pat Robertson on the right, two charismatic preachers representing either end of America's political spectrum. Similarly, there was a fairly broad selection of personalities and public styles when the campaign began: the folksy Paul Simon, avuncular senator from Illinois; the exuberant, nearly chirpy Jack Kemp, the pro quarterback and Buffalo congressman; the passionately sincere Bruce Babbitt, former governor of Arizona; the brooding, irascible Bob Dole of Kansas, the Senate minority leader who had been the GOP vice presidential candidate in 1976 and had been broadly blamed for the ticket's defeat; the gentlemanly Pierre duPont, former governor of Delaware, always proper, always in control; the impetuous Alexander Haig, who'd offered his resignation as Secretary of State one too many times to Ronald Reagan; and the ebullient but curiously stiff Senator Albert Gore, Jr., of Tennessee.

By late February of 1987, only Governor duPont had officially begun his campaign but within a few weeks after Governor Cuomo had said, once and for all, he hoped that he would not be in it, the parade of declarations began. I flew out to St. Louis to watch Congressman Richard Gephardt's kick-off in the city's old railroad depot, recently refurbished and reintroduced as a shopping center, complete with hotel and fancy restaurants. He struck me as probably a little more spirited and lively than his opening speech and others to come suggested. His public oratory was wooden, a bit stilted, I thought, and besides he was fighting a long pattern in American politics of members of the U. S. House not faring well as presidential candidates. (Morris Udall, during his unsuccessful pursuit in 1976, once playfully denied he was a congressman after a flowery introduction that listed his accomplishments and achievements in the House. "I categorically deny ever having set foot in that damned place," he chuckled. It didn't help, of course.) Late that night, after Gephardt's first full day of campaigning, which included a quick blitz of next-door Iowa, he returned to the railroad-station for live interviews on the local television channels. He was wearing black-tie, having just finished an appearance at a lavish fund-raising banquet. Despite his sartorial splendor, he seemed altogether wilted. A ruddy fellow, his face was pale, nearly ashen, and as I watched from a nearby corridor, he sat stoically in a large leather chair as an assistant carefully applied pan-cake make-up to his cheeks and nose.

"And don't forget the eyebrows," the congressman said.

Michael Dukakis, of course, had the eyebrows. On the day before Saint Patrick's Day, he presented them and himself to the press in the Massachusetts State Capitol and said he was announcing that he would announce. He had been drawn into the race in part by Cuomo's flat declaration that he would not be in it—much to the relief of John Sasso, the Dukakis chief-of-staff. Sasso reasoned that two northeastern governors in the Democratic race would be one too many. He had stayed in close touch with Cuomo and his staff but, like much of the media, had never quite been able to discern whether Cuomo would or would not—and if Cuomo did, Dukakis wouldn't. That night, Sasso and I met for a drink at the Ritz Carlton in Boston. "We're going to win it," he said quietly, "mainly because we've got a terrific candidate

but also because we're going to have a lot more money than anybody else."

I more or less believed him—though I would not have believed what was about to happen to the Democrats, and very soon.

The rush of official announcements by the Democrats would continue: Babbitt, in an old mill in Manchester, New Hampshire; Simon, at Southern Illinois University in Carbondale, not far from his home in Wakanda; at another railroad station, this one in Wilmington, Delaware, Senator Joe Biden, who then rode the train to Washington, as he did every day, neither confirming nor denying that he had undergone a hair-transplant. The one still most vivid in my memory took place on the side of a mountain just on the edge of Denver.

It was April 13, 1987. As a crowd of more than a hundred reporters, correspondents, photographers and cameramen waited in a chilling mist, Senator and Mrs. Gary Hart came driving up in a four-wheel drive recreational vehicle. Someone had already noted the absence of a lectern or a microphone for the candidate-to-be, but that little mystery was solved when, from inside the big wagon, Hart was heard talking to his wife and to an assistant, apparently forgetting he had already been rigged with a radio-frequency microphone. The transmitter was in the pocket of his jacket. The receiver was in the public-address system installed on the mountainside. "Well, here we go," he said, his voice reverberating across the landscape. "And this time, it's for real."

Nineteen days later, my wife and I went to dinner at the home of our closest friends in Washington, both journalists. After the meal, we lingered at the table over coffee and discussed the various candidates and their campaigns, coming finally to Senator Hart's. All of us knew him, some better than others, and one of us raised the subject of his private life and wondered whether that might not become a problem for his candidacy.

"No, no," I said authoritatively. "Whatever problem, as you put it, he has is under control. I've talked to his key people, including some of his closest pals, and they tell me

he's absolutely a changed man—that he's got his life under control, that the marriage is better than ever. I think they're telling the truth, so I don't think we're going to hear much about that."

My wife, for one, cast a dissenting vote. "He hasn't changed," she insisted. "That's not something you change overnight. It's going to continue and I think somebody's going to write about it, and it'll be over for him."

"No, no, no," I said. "That's not going to happen."

Late that same night I received a call from the ABC News overnight desk. The slotman had just read a photostat-copy of the *Miami Herald*'s front-page, and for the next few days, I found myself scurrying around the East Coast with a very desperate Democrat. He made a defiant speech in New York City, indicting the media, exonerating himself, presenting a defense that seemed to suggest that he'd never heard of Donna Rice, much less met her or spent the night with her in his Washington home, and then he had hurried up to New England to continue his campaign as though absolutely nothing had happened.

On May 6, his long and, as usual, well-informed address on foreign policy at Dartmouth College was well-received by the standing-only crowd of students and faculty. I approached Hart's old friend, Richard Lamm, the former governor of Colorado and a visiting professor on the campus, and asked how he evaluated the situation.

"I'm still in shock," he said.

What about him, I asked. How's he doing?

"Oh, he doesn't think he's got a problem," said Lamm.

Minutes later, I wedged myself into a battalion of reporters and found myself a small space on the floor of a banquet room in the venerable Hanover Inn. Hart came in, smiling and jocular, and planted his feet a few feet from my knees. For all practical purposes, it was over in the next five minutes. Paul Taylor, of the *Washington Post*, asked how the Senator viewed the moral admonitions of the Judeo-Christian tradition, say for example, the Ten Commandments of the Old Testament. The question was much akin to the

feint of a fine boxer, setting up his opponent, drawing him into serious vulnerability.

Hart responded by saying that he regarded such Biblical moral instruction as reasonable and right, although he certainly didn't want to get into a debate on comparative theology.

Then it came, quickly and straight to the chin.

"Senator," said Taylor, "Have you ever committed adultery?"

The Hart campaign was effectively over, though it officially lasted that time for two more days and then struggled through a later 77-day resurrection. There were jokes about the beast that would not die, but finally the senator gave up and went home. Almost nobody noticed he'd left.

But his initial departure, in May of 1987, had radically altered the Democratic campaign, for Hart had been the front-runner, the odds-on favorite to capture the party's nomination. The race was suddenly wide-open among the Democrats, but the campaign in both parties had abruptly taken on an uglier, meaner tone.

From where I stood, it didn't look much like fun.

Senator Biden was next. In September, Dukakis campaign manager John Sasso orchestrated a press exposé of Biden's uncredited and unacknowledged use of speech material from the British Labour Party leader, Neil Kinnock, as well as from more predictable sources, such as John and Robert Kennedy and Hubert Humphrey. Biden soon departed.

But then, so did Sasso and a couple of his aides who had helped prepare the so-called attack video, really nothing more than a video tape comparing the Kinnock and Biden remarks. Sasso's mistake was that he had not told Dukakis in the first place and had not immediately admitted after the fact that he had prepared the tape and released it. Dukakis fired him, the first of *his* many serious mistakes. It was an example of the new age in politics. In the old days, a political aide who found an opponent vulnerable on the same point would simply have put together a text of the remarks in question and passed it around to reporters. Sasso had done precisely the same, except that in lieu of the mimeographed or photo-copied paper, there was the

video-tape. I never understood the difference. I would have given him a raise.

My vision of the campaign was crumbling. It was still more than three months until the Iowa caucuses and the original field of eight Democrats was already reduced by twenty-five percent, and, besides their own parade of kick-offs and announcements, the Republicans had not yet begun to fight, not even very seriously among themselves.

I assumed they would, however. There was already bad blood between Dole and Bush, Dole and Kemp, Dole and Robertson, and Dole and just about everybody else on that side of the ballot.

In retrospect, I realize now, while I had anticipated that the campaign of '88 would serve as some form of referendum on Ronald Reagan's stewardship of the White House, I badly underestimated the extent to which it would also be dominated by the sense of him—his shadow, his voice-prints, his almost spectral presence in every aspect of the campaign.

He was not a candidate and would not become one; yet his image almost inexorably became as much a candidate as those actually running. In Iowa, for instance, where his popularity among the most faithful Republicans was waning, Senator Dole finished first in the caucuses. Robertson was second and Bush, saddled whether he liked it or not with the Reagan-legacy, a poor third, but in New Hampshire, where Republicans are of a more conservative bent and where, not incidentally, the Reagan-years had been a boon for the local economy, the Vice President came roaring back. That pattern would hold. Wherever the President was popular ideologically or wherever the economy seemed to be holding for the white middle-class, Bush was the winner. Robertson, arguably mean-spirited for a clergyman, nonetheless brought a chuckle when he finally bowed out. "Nobody in his right mind would have challenged Reagan for the nomination," he said, "but that's what we all wound up doing."

And the Vice President, of course, benefited from the President's invulnerability to all manner of sleaze and scandal lapping around him. There had been so many indict-

ments and resignations that, frankly, I had stopped counting long before; and yet Reagan remained the ever-popular Gipper in the American mind, as in Speaker O'Neill's cartoon. He couldn't remember the names of his Cabinet members or visiting heads of state. He fell asleep during an audience with the Pope. He presided over the construction of the largest Federal debt in American history. He promised never to raise taxes but signed 13 different tax increases, and then denied that he had. At first, he denied that his sale of arms to Iran was somehow a deal for the American hostages in Lebanon; later, he said, yes, it had turned into such a deal and that it had been a mistake, and still, while it suffered momentarily, his popularity remained high. Even after his White House, without his knowledge, he said, used the profits from the arms-sale to subsidize the illegal supply of arms to the Nicaraguan contras, public opinion was steadily favorable for Reagan. As a consequence, he became the prime factor in the 1988 process. All the campaign ever was, all it would become, all its candidates and all its issues and arguments, everything and everybody involved somehow related to the elderly fellow in the White House, was somehow compared to him, and somehow examined in the reflected light of his presence there.

Consequently, the campaign was inevitably shaped and formed in his image—his simplistic image. He was, of course, a hero and a genuine icon to millions around the country, perhaps because he had always taken such an uncomplicated view of the world, not all that different from the perspective of the Hollywood sound-stages from which he had risen. From time to time, he had even offered as factual anecdote the plot-line of some film he'd seen or appeared in, generally evoking some stirring impulse of patriotism or brotherly love or interracial harmony. He constantly tried to create the possibility of returning to an America that he seemed to remember so well and could sketch so well but an America that never really existed. Nevertheless, much of the country bought it or wanted to buy it. It was only natural then that the millions and millions who were devoted to him began to see the world as he did—

simplistically, in black and white, with a minimum of nuance.

The society, in general, came to reflect the Reagan preference for symbols as opposed to substance, to disregard fact and rely on the loftier fictions available. There were good guys and bad guys, black hats and white hats, and subtlety was akin to original sin. As the society came more and more to resemble Ronald Reagan, so did the 1988 campaign. Labels

> All the campaign ever was, all its candidates and all its issues and arguments . . . somehow related to the elderly fellow in the White House.

were superior to logic, and painless panaceae were preferred to real policy. Illusion seemed to work as nicely as reality, thank you, and baser instincts were superior to intelligence.

In this simplistic context—the world according to Ronald Reagan—complexities were unwelcome. Any individual campaign that offered even a slightly complicated view of the country and its problems was quickly dead—Babbitt's, for example—and, of course, there was the eventual, inevitable demise of any candidacy who happened to challenge the Reagan *Weltanschauung* even in the mildest of terms—Dole's, for example.

It was in Dole's loss to Bush in New Hampshire that the other essential aspect of the 1988 campaign presented itself quite clearly. It would require of its survivors, on the one hand, the simplistic vision of Reagan, but it would also demand of its winners the blank-faced willingness to be as downright nasty as necessary.

Dole had emerged from his Iowa victory not only as the front-runner but as the likely Republican nominee. Bush, on the other hand, was variously described as crippled, bleeding, wounded, doomed, and hopeless.

New Hampshire would make or break the Vice President.

Roger Ailes, his media guru, knew precisely what to do. On the Thursday before the Tuesday primary—the last day advertising

could be purchased on either the Manchester television station or the Boston channels—he purchased at the very last minute time for a commercial he knew could not be answered by Senator Dole. It was called "Straddle" and included, over two facing pictures of Dole, a narration that accused Dole of trying to straddle the INF treaty issue until Iowans had forced him into supporting it and of doing the same with an oil-import fee, and deduced

A campaign ought to be a national banquet that celebrates the Republic's strengths and strengthens the Republic it celebrates. . . . 1988 was not.

that, since he had never actually promised not to raise taxes, he would no doubt do precisely that. In between these charges were impressive portraits of Bush and such opposite claims as, Bush led the fight on the INF treaty for Ronald Reagan, was against an oil import tax, and won't raise taxes. Besides the really rather specious boast that the Vice President had somehow been Reagan's INF point-man, Ailes gave the ad another distinct touch. He reversed the negatives of the Dole pictures so that, in one of them, his hair was parted on the wrong side and his general appearance was slightly off-balance, nobby-headed, peculiar.

Of course, it worked beautifully. Dole was unable to purchase any time to answer the ad, and there were too few days left in the campaign to refute it through the free media. He'd been had, and, in a way, that was it for the Republicans. On the night of the primary, when it was clear he had lost, he appeared on NBC with Tom Brokaw, who asked if he might have some message for Bush, who was about to appear. "Yeah," Dole growled. "Tell him to stop lying about my record." It was Dole at his worst, a quick and vivid reminder of why he caught the blame for the loss in 1976.

Roger Ailes and his ads would, of course, continue to play a large role in the Bush march to victory, but after Dole, there just wasn't much in the way of serious competi-

tion in the Republican ranks. Haig dropped out after New Hampshire, and the others followed in fairly quick order so that, in reality, the collection of Southern primaries on Super Tuesday wasn't much of a contest for Republicans. It was clear sailing from New Hampshire on. What the others discovered was that there was simply no way to usurp Bush's role as the son of Reagan, or at least the surrogate, no matter how much fealty they pledged to the Gipper. Kemp, for instance, could legitimately lay claim to a much stronger and longer affinity for the Reagan goals than anybody in the race, but it didn't matter. Reagan had let it be known, at least tacitly, that Bush was his boy, and Reagan was the primary force in the campaign.

That was never more evident than in the string of Democratic primaries in which all the candidates, with the notable exception of Jackson, found themselves fudging to the right, trying to get a little closer than the others to something at least similar to the Gipper's view of the world. There was some weeping and gnashing of teeth over the corruption issue and some wringing of hands about the impact of the growing deficit on the future, but, in the main, even Democratic candidates tried to avoid going after Reagan with any zest. It was an amazing sort of influence. Consider, for instance, the meek battle-cry of Dukakis in his acceptance speech at the Democratic convention. "This election," he said, "is not about ideology. It's about competence." It was ample proof, without additional commentary, that the Reagan mystique had pretty well discredited traditional Democratic approaches. Dukakis and the Democrats were painted as damaged goods even before Bush and Ailes took out their accomplished brushes. Such was the overriding presence of Reagan in the race, and it would continue.

The vision Bush painted of Dukakis was that of a Kennedy-Carter-Mondale continuum of policy and programs—the Reagan component of his effort—and the amalgam of specific ersatz issues raised out of the contemporary campaign. The flap over the Pledge of Allegiance, for

example, wasn't much of an idea, really—after all, the President of the United States isn't going to do a great deal about what goes on in the local classrooms—but it was clearly enough to attract a lot of voters in an electorate happily accustomed to Reagan's picturesque patriotism.

The same was true for the Willie Horton references and television commercials. They struck many as having racist undertones, but beyond that, the issue of prison furloughs isn't high on any president's agenda, and Bush and Ailes and the headquarters brain-trust were well aware of that. It was, as they are sometimes called, strictly a functional issue, a button to be pushed, used to move a voter into at least a negative mode towards the other guy.

In fact, the most effective advertising of the Bush campaign was strictly negative. Its goal, successfully achieved, was to try and define Dukakis in the dimmest and grimmest possible terms.

The Dukakis campaign was inept, badly managed, poorly merchandised, and, even when Sasso finally returned to its helm, essentially incompetent. It was never a match, not even, in my mind at least, when Dukakis held a sizable lead in public polling for a few weeks in June and July. When the governor decided to simply give August away, that was essentially the end of the campaign. Dukakis frittered around, mostly in Massachusetts, until Labor Day or thereabouts while Bush was out and about murdering him with paid media and free media as well—most of it unanswered. From the commercials to the debates, no matter who seems to have "won" which one, there was never much of a contest. Even Lloyd Bentsen's complete put-down of Dan Quayle in their debate, while momentarily effective, made little difference in the long run.

It seemed slightly odd then that, even in mid-January of 1989, the man who would soon be the President of the United States was still trying to explain his candidacy, still trying to define his campaign, still defending it as a noble exercise in democracy. The end—the happy, celebratory inauguration—had to provide that silken justification of the means. Or did it?

Frankly, nobody really cared by then. It was over and done. He had won. Why try to justify it?

But that's what he was doing.

"Last year," Bush told Republican loyalists at a Washington hotel, "our two great parties offered candidates and platforms with sharply contrasting ideas on the full spectrum of national issues.

"We spelled them out thoroughly and in great detail in all fifty states, in nationally televised debates and in hundreds of speeches, fact-sheets, briefing-papers, proposals, and initiatives.

"An intelligent, informed decision was possible—even obvious—and a choice between men and messages was made by the American people. Where they agreed more with my opponent on the issues, he won their votes, and where they agreed more with me, I did.

"It's just that simple," he concluded.

Listening from the back of the room, it dawned on me that perhaps I'd devoted eighteen months of my life to the wrong election. Clearly, the one described by George Bush that afternoon bore no resemblance to the one I had covered.

It is neither too idealistic nor unrealistic to expect that an American presidential campaign ought to be a national banquet, a lavish feast that celebrates the Republic's strengths and strengthens the Republic it celebrates. Many American presidential campaigns have been precisely that.

Unfortunately, 1988 was not one of them.

Instead, it was such a dreary dish that almost half the electorate simply declined to partake. Many folks *just said no* to both parties and all their candidates, to the sophomoric commercials, the simplistic reportage (including my own), and to an entire season of kindergarten games and back-alley brawls.

No wonder.

It was consistently joyless, often childish, sometimes churlish, and frequently downright nasty—a celebration of cynicism that neither served the American people nor enlightened them. The hindsight of Mr. Bush notwithstanding, that was the 1988 campaign. It was considerably less than the country deserved—and it wasn't much fun.&

THE CANDIDATES

GARY HART

Entered race April 13, 1987 *Withdrew May 8, 1987*
Re-entered race December 15, 1987 *Withdrew March 11, 1988*

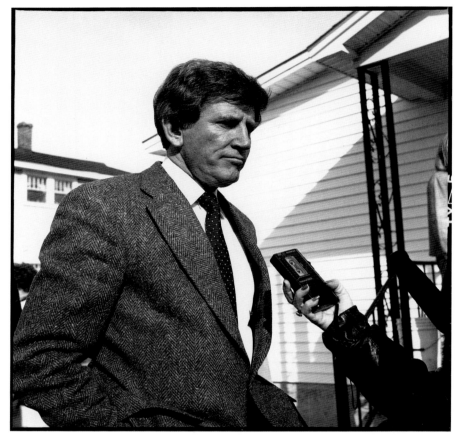

February 3, 1988 Manchester, New Hampshire

He enjoyed being an outsider, took pleasure from it and pride in it. He wore it like a badge, exploited it and embellished it, often choosing not to belong even when he was invited. This may have been an immutable trait, but it also became his preferred persona. From his Kansas boyhood to his national notoriety, he seemed to have floated through the moments of his life without brushing against their contours. In the hyper-gregarious world of American politics, he slapped no backs and kissed no babies. Keenly intelligent, perhaps even brilliant, a voracious reader and graceful writer, he was a man of exceptional talents who attracted and enlisted others with similar gifts, yet never seemed capable of knowing them. Reciprocal relationships were difficult, genuine friendships rare. He was aloof, occasionally arrogant, self-absorbed, a moody brooder, always the loner—and yet, he had driven himself relentlessly through the intricate labyrinth of power right to the very edge of his dream. In 1988, the Democratic nomination and quite possibly the White House were realistically within his reach. Even so, he was either an extraordinarily careless man or compulsively self-destructive. In either case, in the end, he was outside…again.

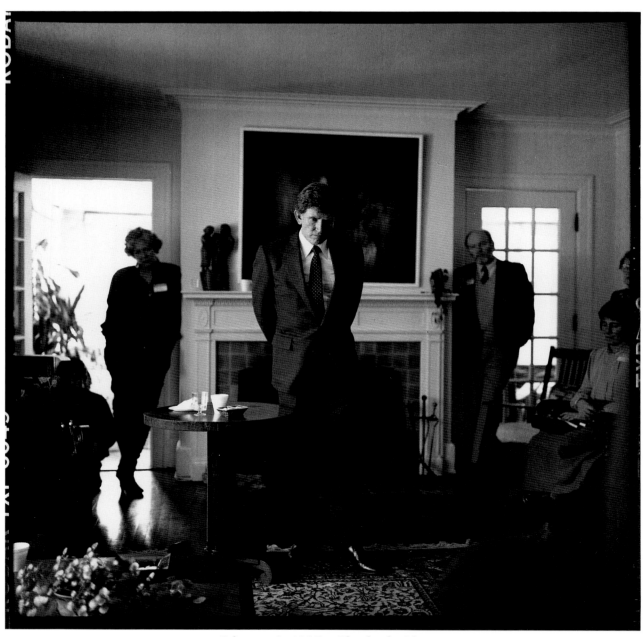

February 8, 1987 Cleveland, Ohio

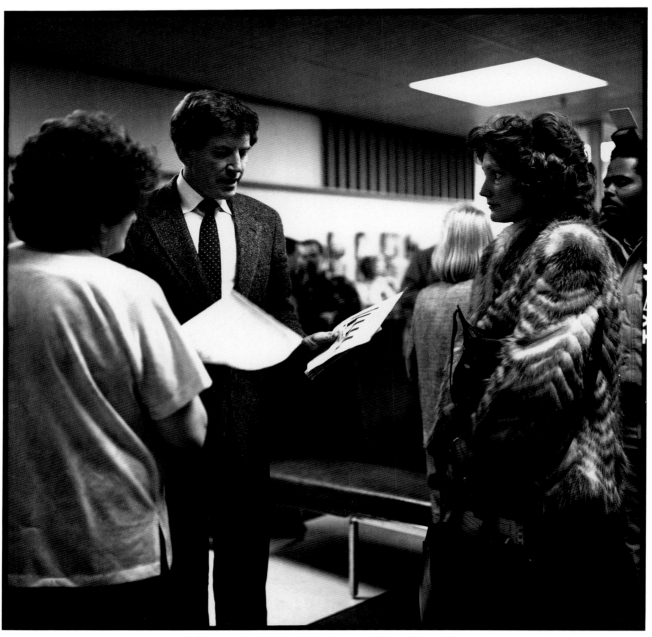

February 3, 1988 Manchester, New Hampshire

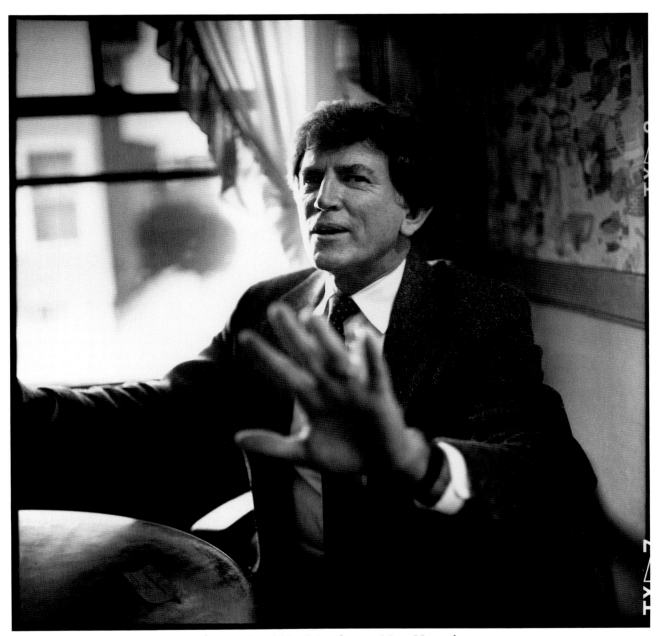

February 3, 1988 Manchester, New Hampshire

ALEXANDER HAIG

Entered race March 24, 1987 Withdrew February 12, 1988

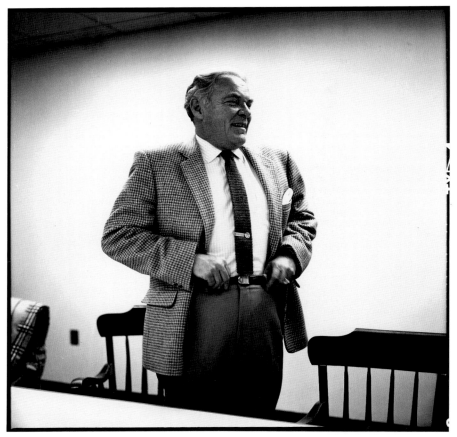

February 1, 1988 Durham, New Hampshire

Even as a civilian politician, he always looked like the spit-and polish soldier he had been, all razor-sharp creases, straight lines, and crisp right angles. Years after Korea and Vietnam, he was still the eternal West Pointer at permanent attention or, in the most relaxed moments of his campaign, nothing less military than parade rest. There was a much lighter side to him, of course—he was quite an accomplished raconteur, for instance; good company over drinks and dinner—but it surfaced so seldom and passed with such flickering speed as to be rarely recognized by the voters, most of whom saw only the brigade commander, cleaned and pressed, stiffly starched. Their coolness toward him was a constant puzzlement for him. After all, he knew he knew more about the White House and international diplomacy and military strategy and even business and commerce— about everything, for Pete's sake!—than anybody else in the race. Why then, he wondered, was his campaign a failure? The answer was both in his stars—the ones he had worn—and in himself. All the other generals who'd made it to the White House were veterans of popular wars they'd helped America to win.

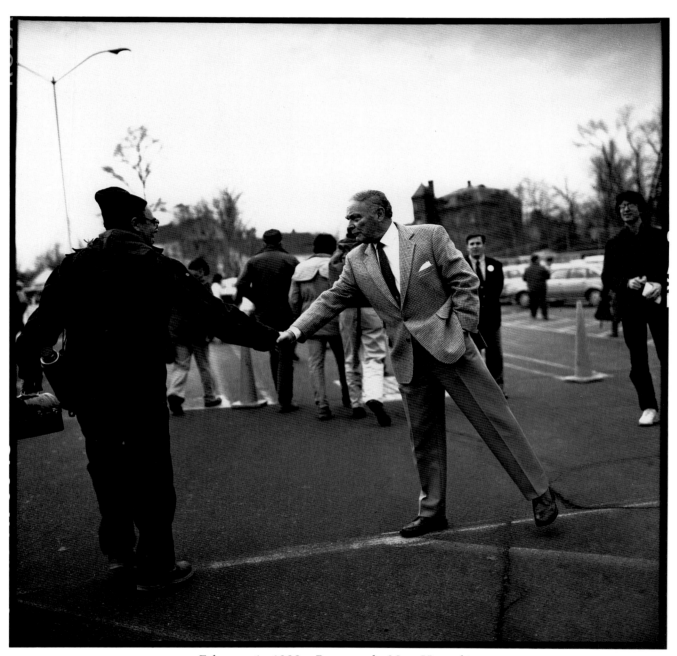

February 1, 1988 Portsmouth, New Hampshire

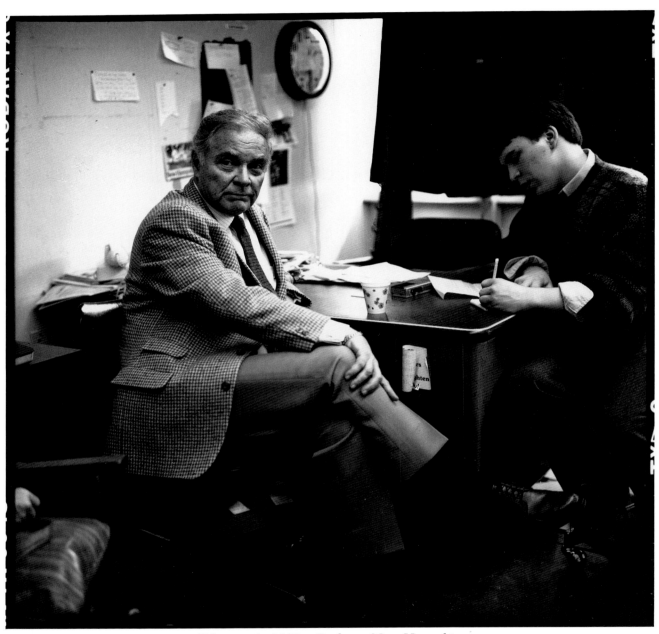

February 1, 1988 Durham, New Hampshire

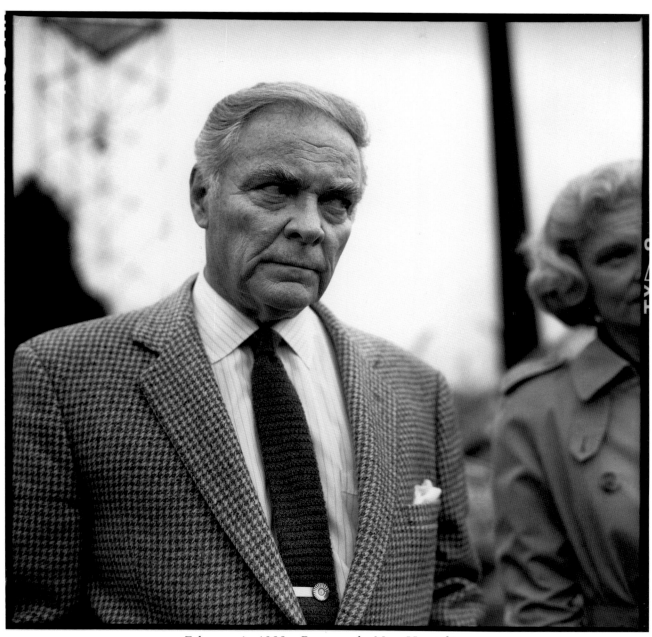

February 1, 1988 Portsmouth, New Hampshire

BRUCE BABBITT

Entered race March 10, 1987 Withdrew February 18, 1988

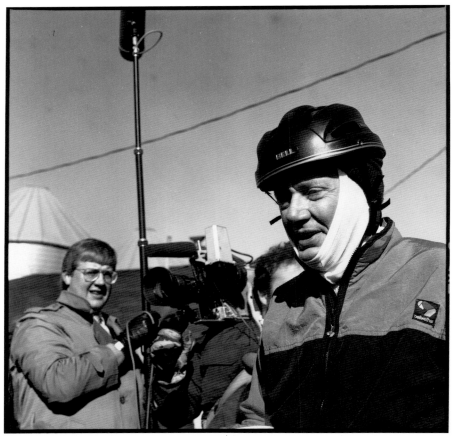

February 6, 1988 Perry, Iowa

He was not your garden-variety politician. In an age when television had become the essential conduit between candidate and voter, he clearly wasn't very good at it, wasn't comfortable with it, seemed incapable of dealing with its demands. Not that he didn't try. If they can teach Mr. Ed to talk, they can teach me, he chuckled—but the lessons didn't help. He still swallowed his words in large gulps, still stepped on his own best lines…and still laughed about his flaws, his inability to wrestle the great video-beast to the ground. He was irrepressibly ebullient, a happy campaigner however his campaign was faring. Witty and self-deprecating, he was apparently immune to the microbes of egotism that commonly infect those who seek the White House. It was a serious pursuit, though, and daring, for he was essentially a courageous man of serious purpose. He, after all, had marched at Selma in 1965 and, in 1988, when the whisper of new taxes was perilous, he literally stood up for them. Most reporters enjoyed his company and admired his decency. He was quickly, yet gracefully, gone. The campaign was the less for his leaving.

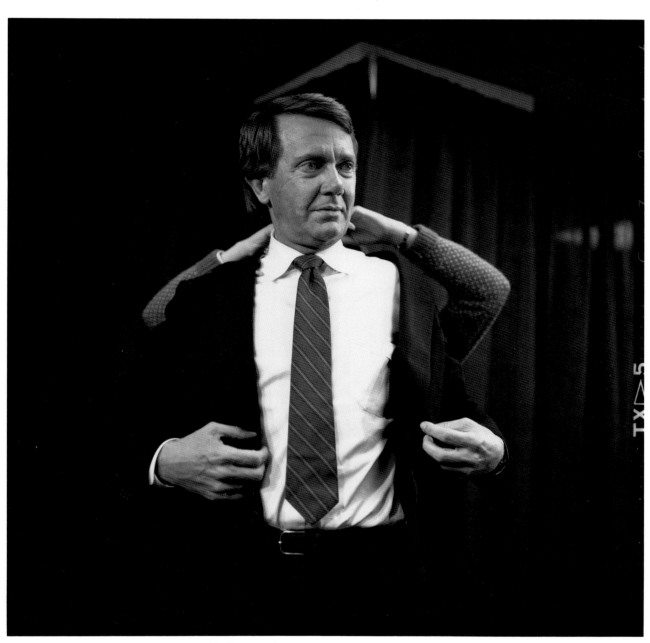

February 5, 1988 Des Moines, Iowa

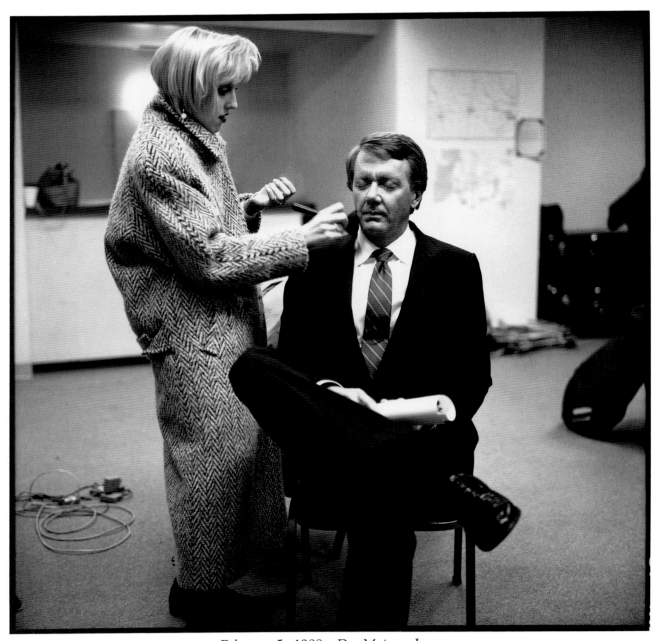

February 5, 1988 Des Moines, Iowa

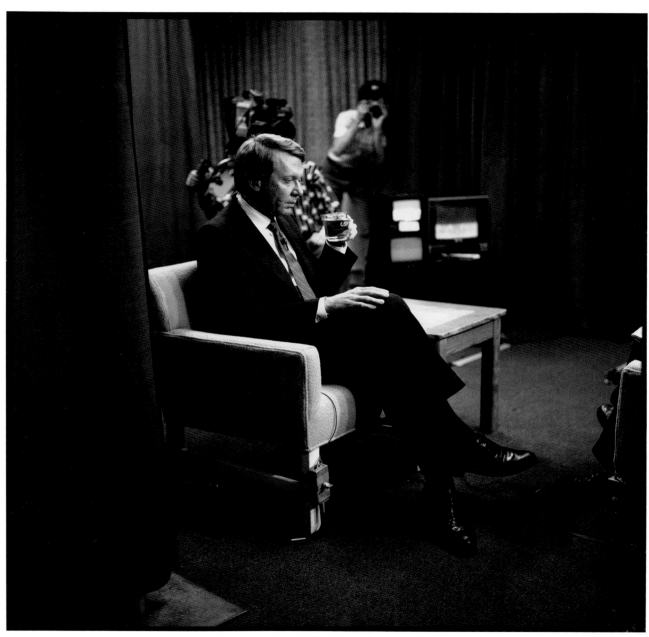

February 5, 1988 Des Moines, Iowa

PIERRE DUPONT

Entered race September 16, 1986 Withdrew February 18, 1988

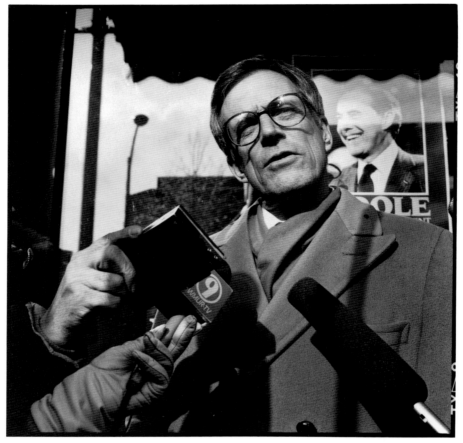

January 26, 1988 Manchester, New Hampshire

Although his last name was known all over the world, his face was unfamiliar to most of the people in the country he was seeking to lead. In fact, he probably had a less promising base on which to launch a presidential pursuit than any of his Republican rivals or anybody else for that matter. He had quit Congress to serve two terms as the governor of a state with fewer people than Pittsburgh, a state whose yearly budget was 27 times smaller than the annual sales of his family's company. Understandably, his campaign would be a painful experience for him. A sensitive fellow, he was never unaware of the overwhelming odds against his success, no matter how diligently he presented himself—and he was nothing if not a diligent candidate, the first of the entire crowd to declare himself in the race, indefatigable in his day-to-day schedule. He was warm and personable, reasonably competent on the stump and fairly adept with television. Still, he could never compensate enough for his perceived aristocracy and never quite recovered from the one-liner that dogged his campaign: would you want a President with the same first name as your maitre d' ?

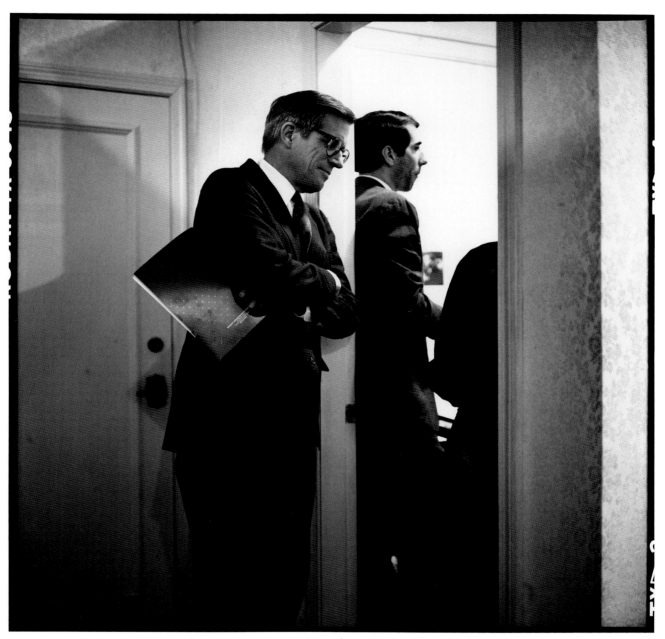

January 26, 1988 Manchester, New Hampshire

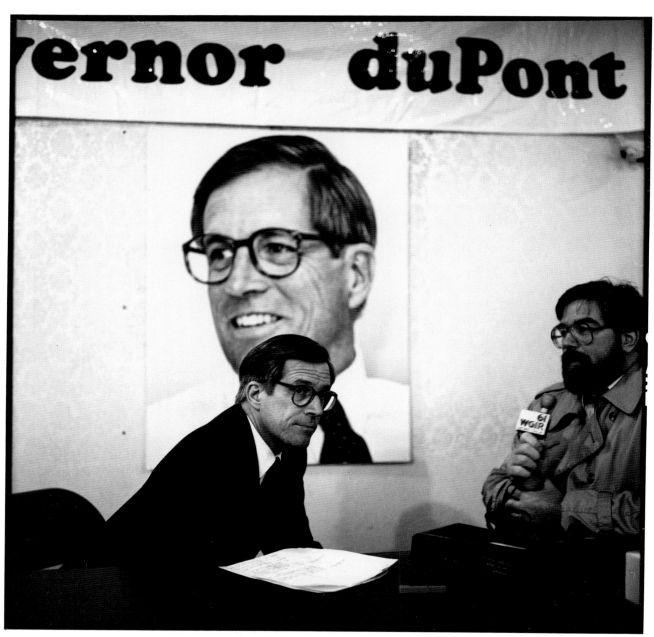

January 26, 1988 Manchester, New Hampshire

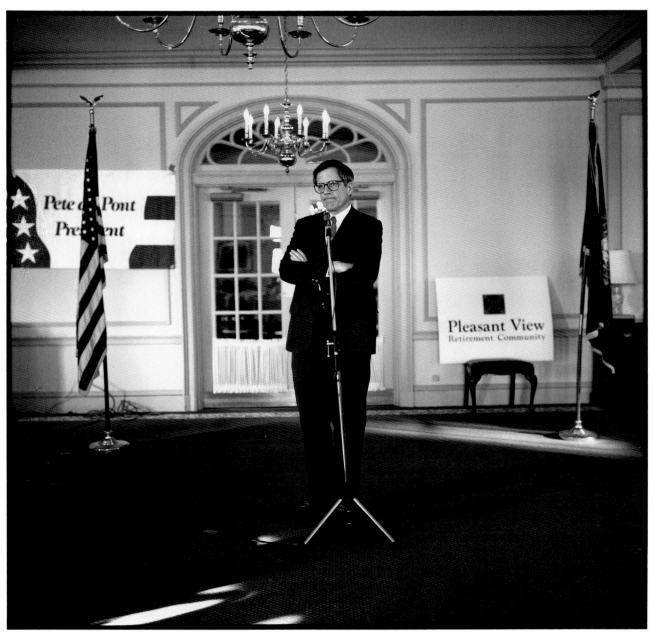

January 26, 1988 Concord, New Hampshire

JACK KEMP

Entered race April 6, 1987 Withdrew March 10, 1988

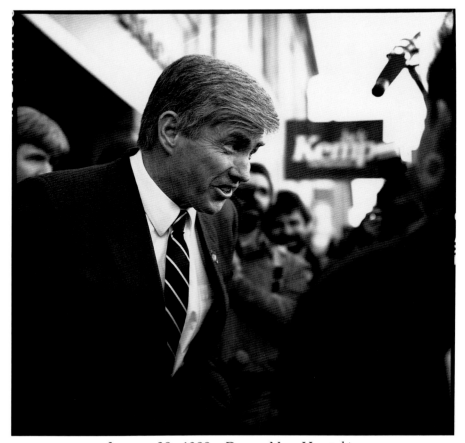

January 28, 1988 Dover, New Hampshire

He had been in politics twenty years and had never lost an election, but, somehow, he was never even within sight of winning anything at all in 1988—and the whole process seemed to bewilder him. After all, his campaign had seemed so promising before it actually began. He would be son-of-Reagan to millions searching for the ideal ideological successor to a President they dearly loved. They would need seek no further than this famous New Yorker with the helmet of gray hair, the only Republican running who had supported the Gipper in 1980, and one of the godfathers of supply-side economics. He had the best smile among all the Republicans and he was one of the more enthusiastic candidates in the history of politics—exuberant to a fault, perhaps. At least he wouldn't be out-hustled by his competitors. Nor would he be out-talked in that parade of 1988 debates, particularly on the minutiae of economic policy. He had been as intense about mastering that as about most everything else in his life. Still, in the public eye, he was neither heavyweight nor dark-horse—and every campaign day was third and long.

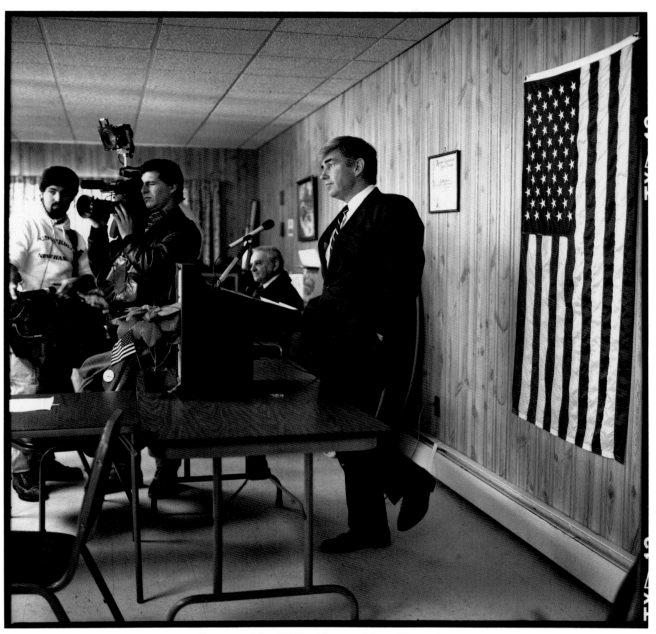

January 28, 1988 Exeter, New Hamsphire

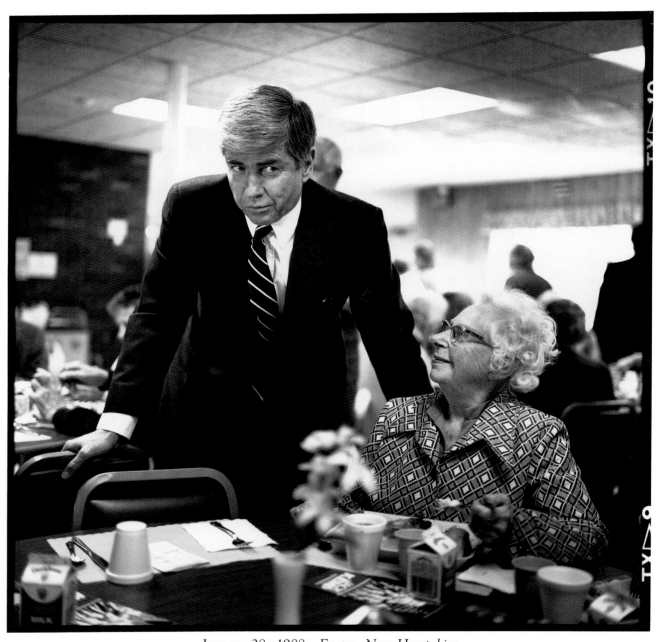

January 28, 1988 Exeter, New Hampshire

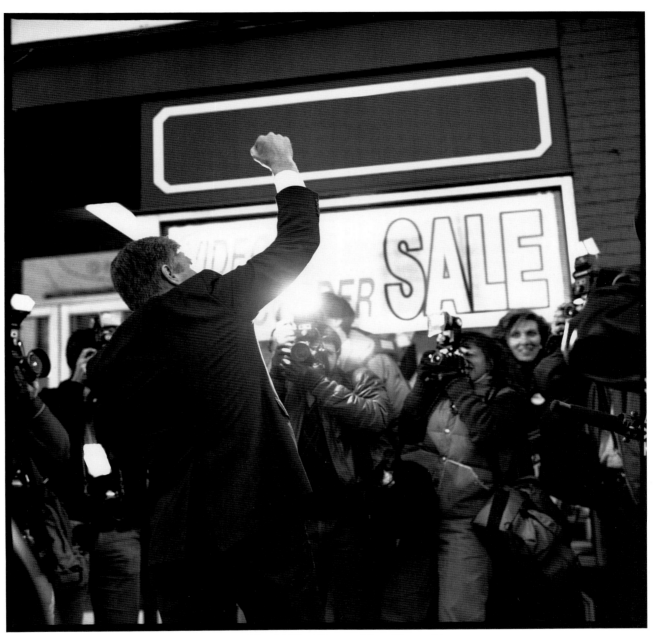

January 28, 1988 Dover, New Hamsphire

RICHARD GEPHARDT

Entered race February 23, 1987 Withdrew March 28, 1988

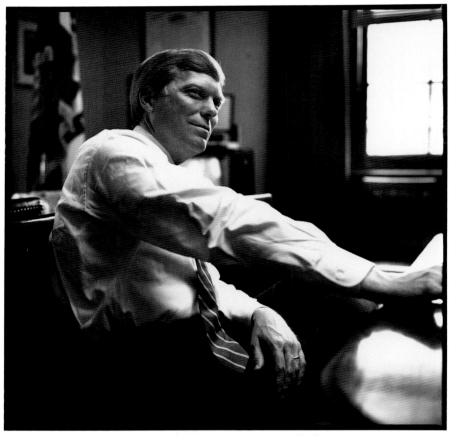

April 9, 1987 Washington, D.C.

He often compared his common-sense pragmatism to the plain-spoken perspective of Harry Truman and evoked in others the fictional image of another Missourian, Huckleberry Finn. There was about him the aura of baseball and apple pie. He was the well-scrubbed boy-next-door, risen from the working class, a straight-arrow Eagle Scout who had devoted nearly two decades of his life to a difficult climb up the tricky ladder to power in the U. S. House of Representatives. He had no doubt that the three basic ingredients of his success in Congress—hard work, hard work, and hard work—would bring him the Democratic presidential nomination as well, and his demeanor reflected that Spartan thesis. He was strictly business, no nonsense, often grim, sometimes dour—all of which seemed an altogether appropriate attitudinal image, given the serious economic inequities on which he was focusing. He presented himself as the champion of the working-class from which he had come, and, even in the transient thrill of his impressive victory in Iowa, he seemed reluctant to enjoy the moment, remembering perhaps that no member of the House had done what he was trying to do in over a century.

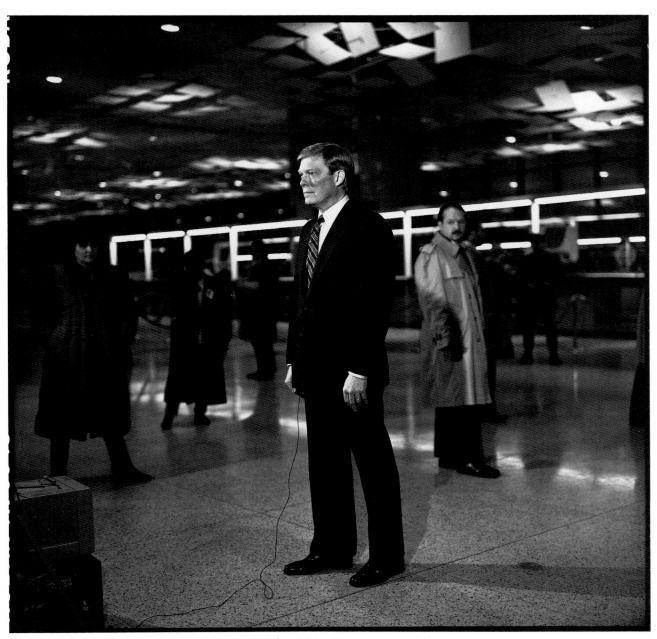

January 25, 1988 Boston, Massachusetts

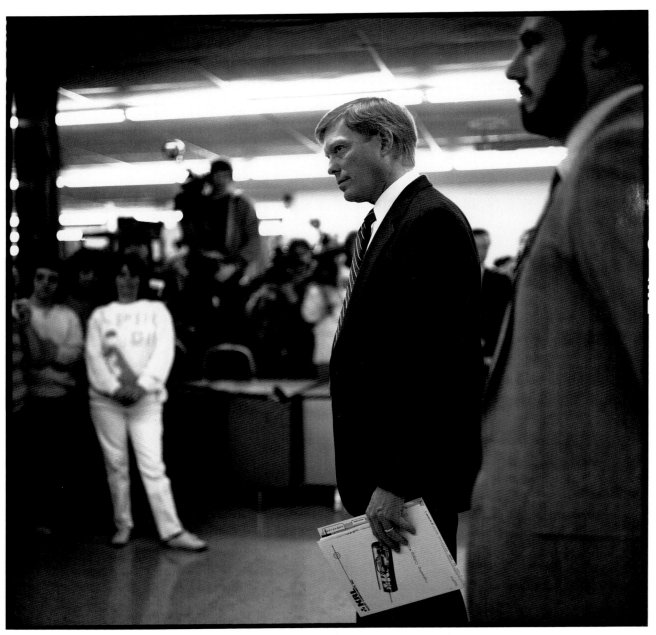

January 26, 1988 Manchester, New Hampshire

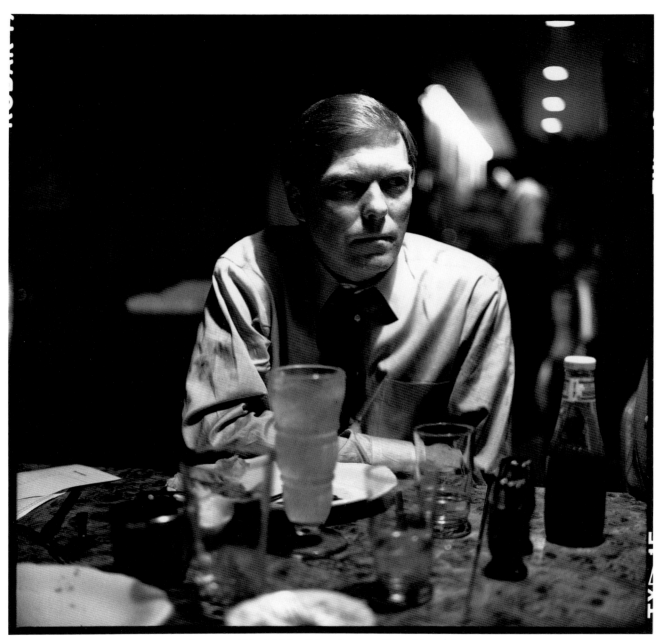

January 25, 1988 Manchester, New Hampshire

ROBERT DOLE

Entered race November 9, 1987 Withdrew March 29, 1988

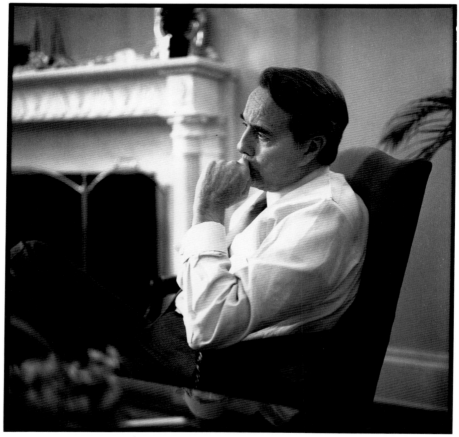

February 6, 1987 Washington, D.C.

In his own words, he was a gunslinger, a tough guy not merely willing to mix it up when the opportunity arose, but also downright eager for a little combat—almost always looking for a fight, and almost always finding one. One of his colleagues in the Senate described him as so consistently and inherently disagreeable, he couldn't sell beer on a troop-ship—and yet, oddly enough, having chosen a vocation that so often punishes a personality such as his, he had been extraordinarily successful for over forty years, unbeatable back home in Kansas. Those who knew him well, even those who knew him casually, recognized that there was considerably more to him than the ill-tempered mask he seemed to wear too willingly and well. He was blessed with a quick intelligence—the dark, deep-set eyes seldom missed the slightest nuance of any context, political or otherwise—and a rapier wit. He was also a skillful legislator, adept in the arcane maneuvering and manipulations of the Congress, no stranger to the compromise and concession common to the making of law. Yet, across the country, he was remembered also and perhaps too well for his snap and his bite.

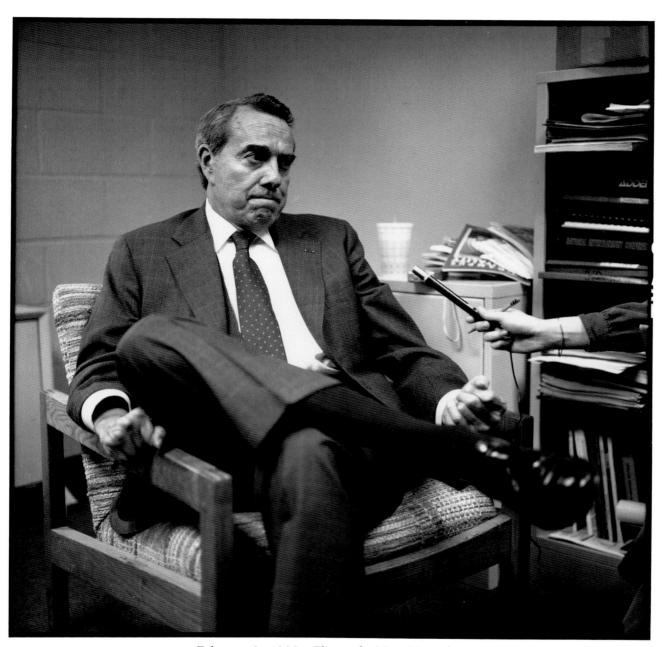

February 2, 1988 Plymouth, New Hampshire

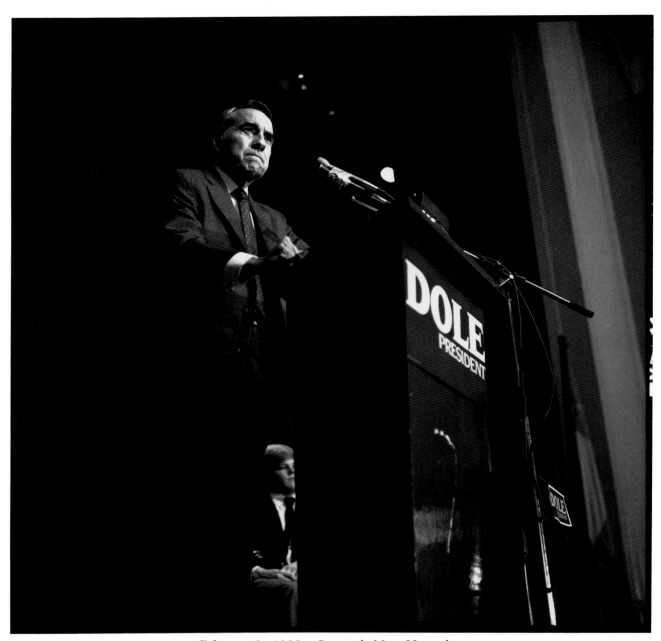

February 2, 1988 Concord, New Hampshire

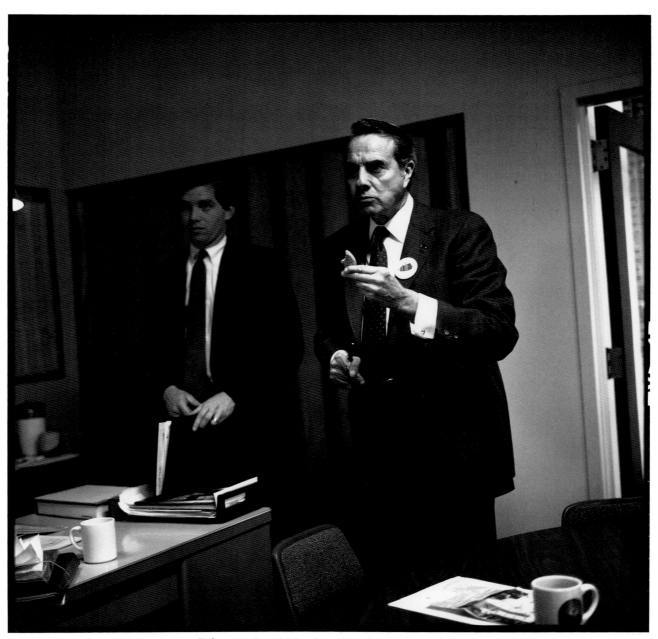

February 2, 1988 Laconia, New Hampshire

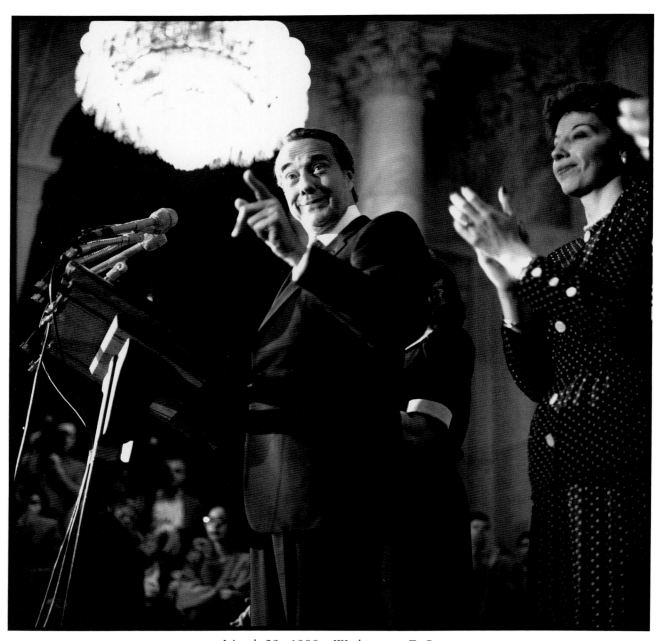

March 29, 1988 Washington, D.C.

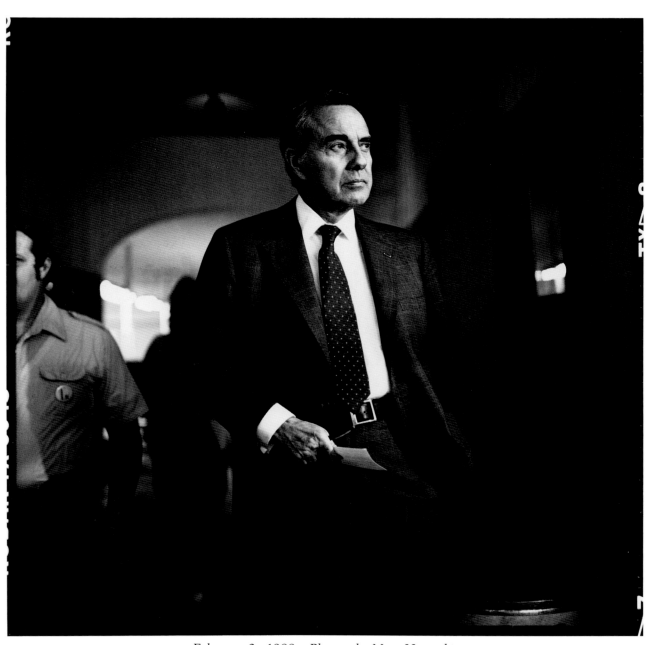

February 2, 1988 Plymouth, New Hampshire

PAUL SIMON

Entered race May 18, 1987 Suspended campaign April 7, 1988

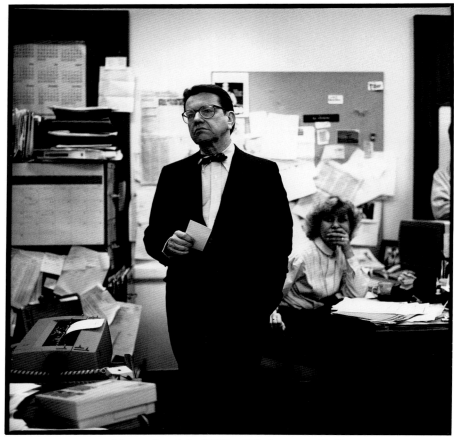

November 16, 1987 Washington, D.C.

While most of his fellow Democrats tended to run like rabbits from any-thing that even resembled the liberal label, he pinned it proudly to his chest, raised it as a campaign banner. That was the essence of a man who had built his career espousing the old-fashioned values of small-town America, his native Midwest. In his halting basso profundo there was the unmistakable certainty of a grown-up who not only knew what it was he believed but knew why he believed it. Still, he was so overwhelmingly avuncular at times, so pedantically professorial at others, that he soon became his own opponent. He prided himself in not adapting himself to the new age in American politics, to the demands of television, and the slick disciplines of public relations. He would hang on to his bow-ties and his horn-rimmed glasses against the advice, he said, of his campaign counselors, and he would not trim his progressive sails whatever the prevailing winds. He was probably the easiest to read of all those in the race. He seemed decent, and he was. He seemed stubborn, and he was. He seemed to know he was swimming against the tide . . . and he was.

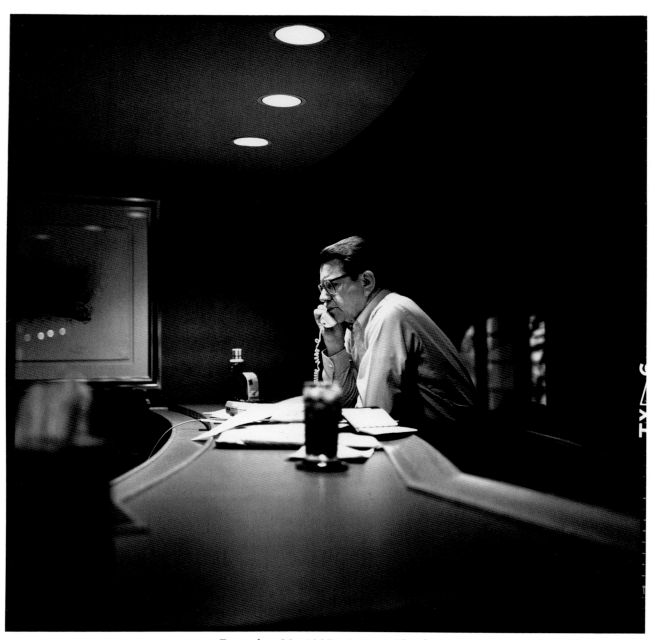

December 30, 1987 Miami, Florida

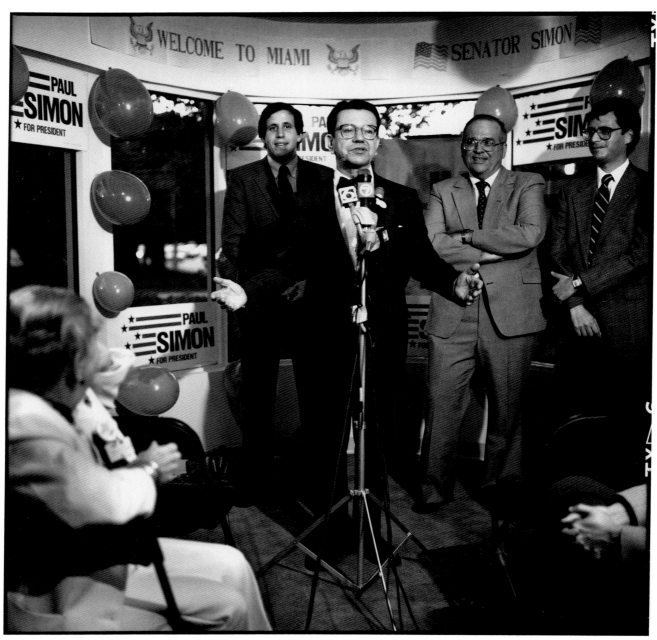

December 29, 1987 Miami, Florida

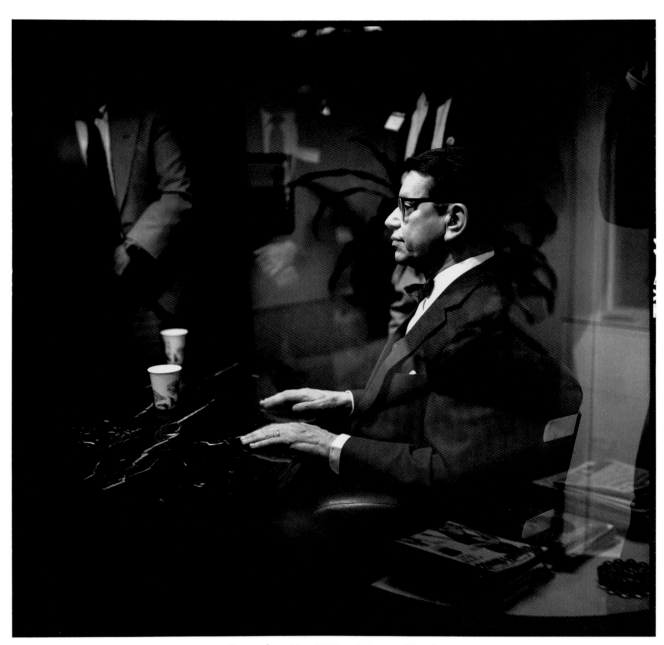

December 29, 1987 Miami, Florida

ALBERT GORE

Entered race June 29, 1987 Suspended campaign April 21, 1988

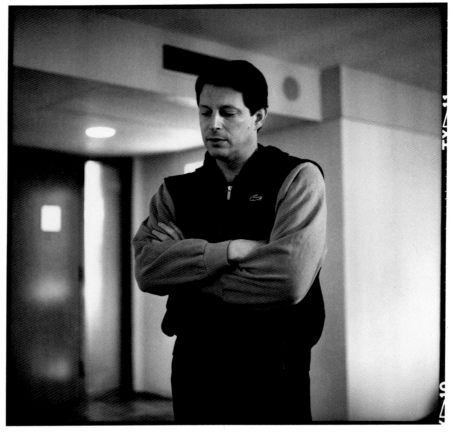

February 18, 1988 Dallas, Texas

From its beginning to its end, his campaign was a precarious enterprise, a genuine high-wire act that constantly pitted his ambition, his instincts, and his intelligence against the gravitational pull of political reality. His most formidable asset was the brute force of the commitment he had made and kept to his candidacy—his unrelenting faith in its possibility, his unwillingness to allow even a modicum of self-doubt to creep into his soul. If by no other means, he would by God win by dint of his dream. Nothing would deter him; nothing could dampen his eager elan. Facts that others read as critical setbacks, he easily rationalized as irrelevant to the larger, longer scheme. Eventually what emerged from this over-arching determination was an unflattering national portrait of him as something of an over-achiever, never less attractive than in his Spring alliance with the Mayor of New York City. But, as in most campaigns, the veneer was deceptive. He was not only answering his genes—his father, once a senator himself, was precisely the same sort of man—he was also building for some future campaign in which his dream would be more realistically within his reach.

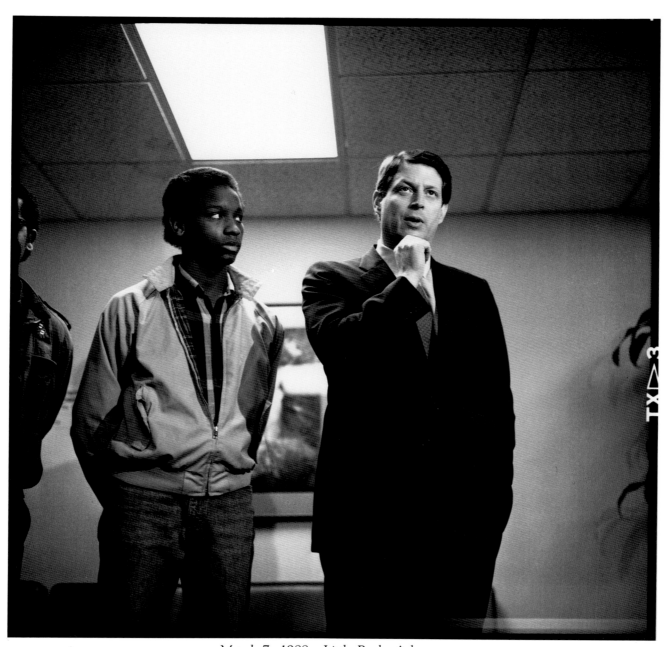

March 7, 1988 Little Rock, Arkansas

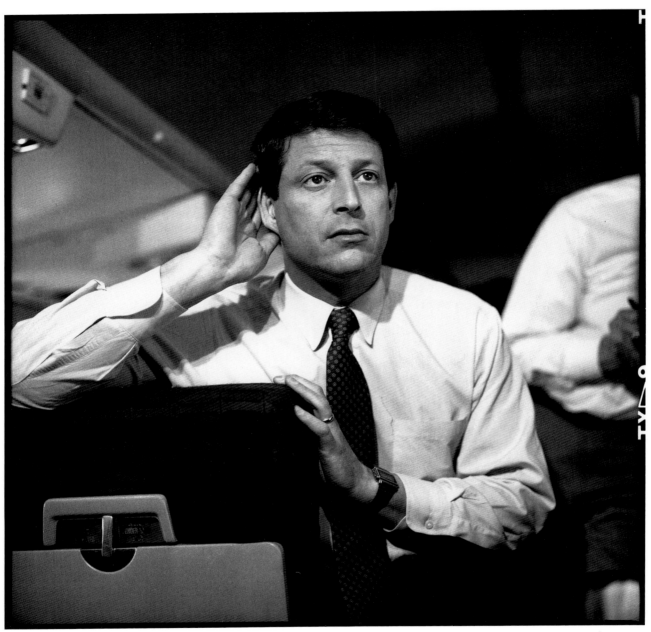

March 7, 1988 Airborne: Houston, Texas—Pensacola, Florida

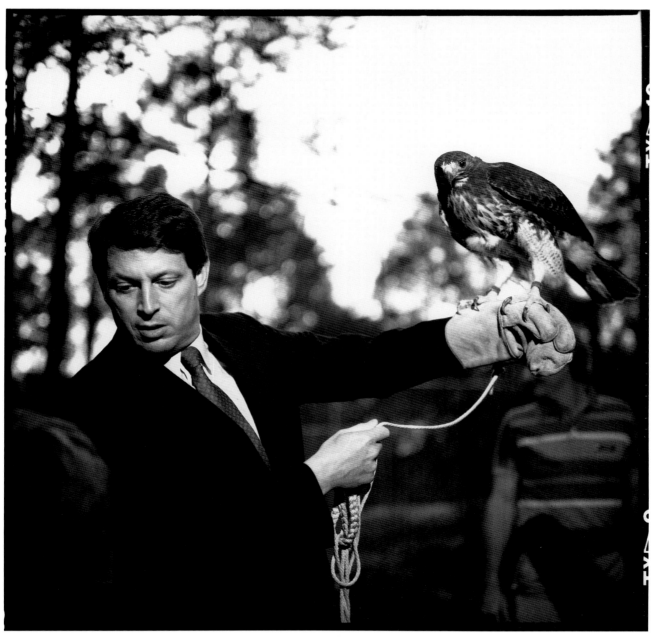

March 7, 1988 Tallahassee, Florida

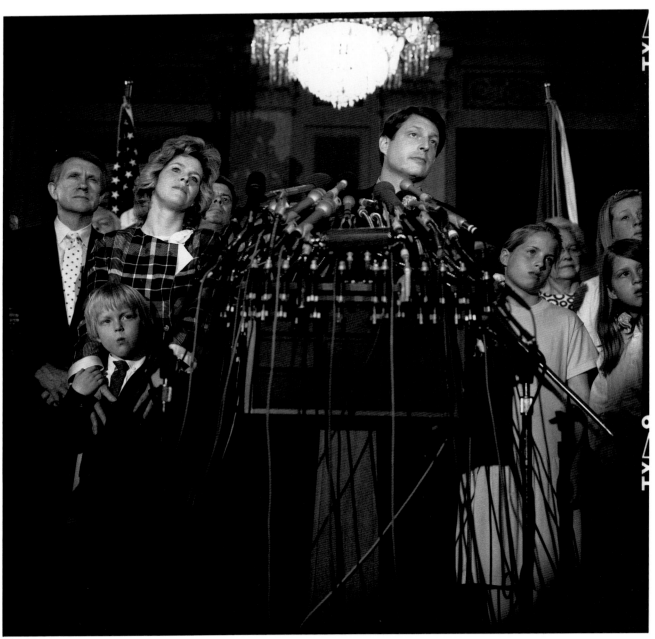

April 21, 1988 Washington, D.C.

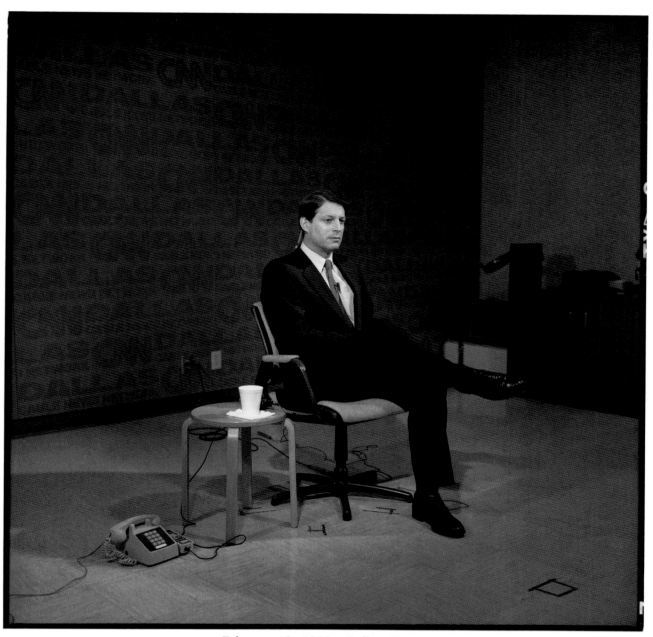

February 18, 1988 Dallas, Texas

PAT ROBERTSON

Entered race October 1, 1987 Suspended campaign May 16, 1988

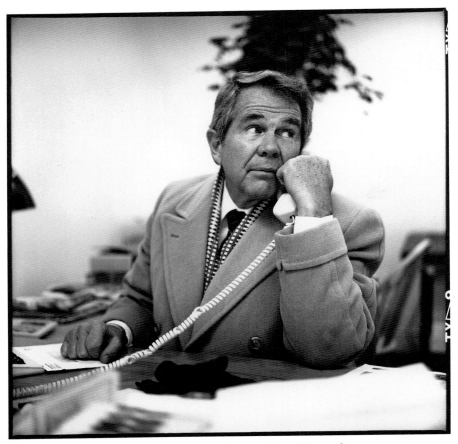

January 6, 1988 Lebanon, New Hampshire

He seemed to be a man perpetually pleased with himself or with the way the world was spinning at the moment—or with something or other, at least. The large smile was always there either on the large face or just at the edge of his mouth, constantly at the ready, visible even in its muscular preparation. It was an utterly fascinating feature, immediately recommending a pleasant personality, a happy fellow residing there behind it—just the sort of candidate who does well for himself in person and on camera. The smile seemed to produce a thousand little crinkles and crevices in his countenance, suggesting a bubbly good-natured owner, fond of laughter, easily amused…until the eyes began to register. The eyes were the never-changing opposite of the smile: untrusting, humorless, impatient, threatening. He used his eyes and his smile together to convey the dichotomous structure of his campaign, perhaps his life—the unyielding tension between clerical kindness and the practiced superiority of the moral snob, the stark and striking contrast between compassion and condescension. He was chillingly consistent with his eyes and his smile. The look was there both when he announced and when he departed.

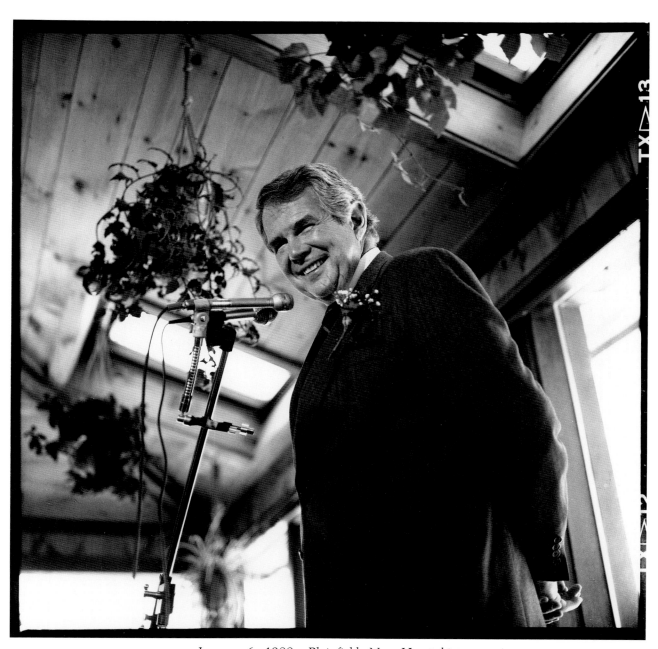

January 6, 1988 Plainfield, New Hampshire

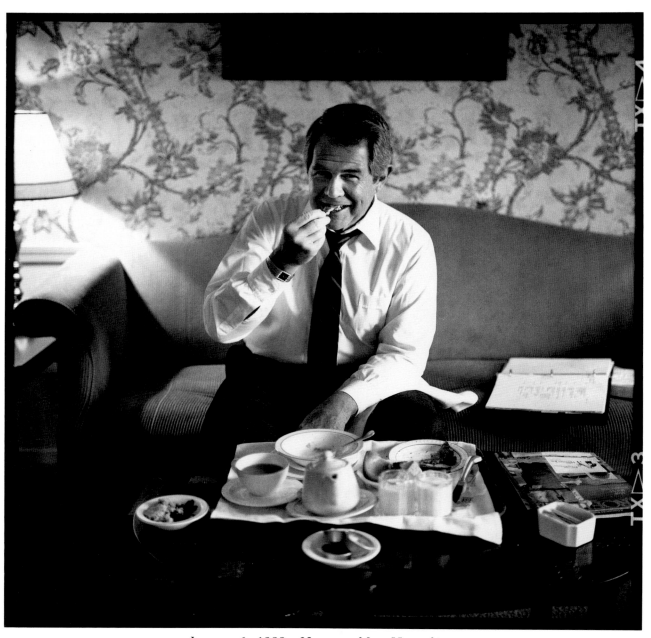

January 6, 1988 Hanover, New Hampshire

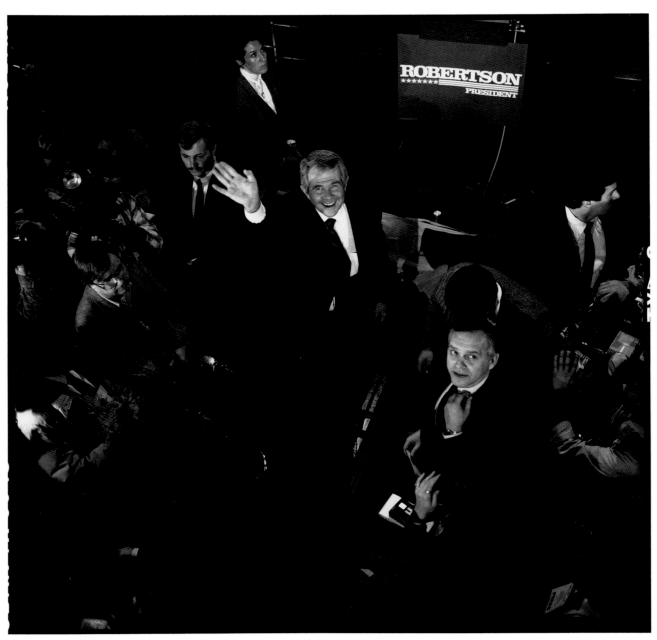

February 8, 1988 Des Moines, Iowa

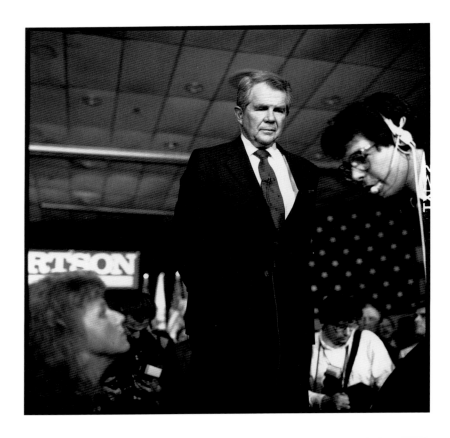

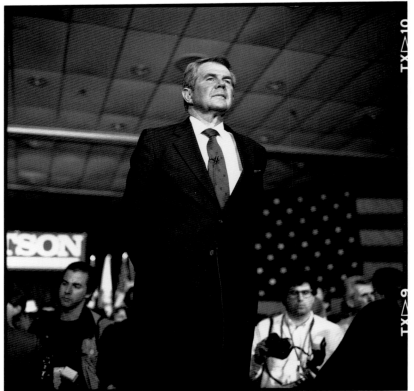

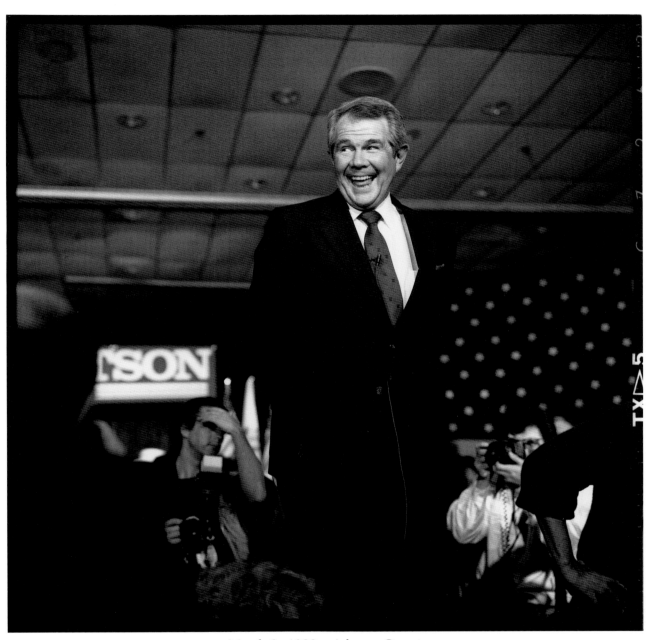

March 8, 1988 Atlanta, Georgia

JESSE JACKSON

Entered race October 10, 1987 Campaign ended July 20, 1988 (with formal nomination of Michael Dukakis)

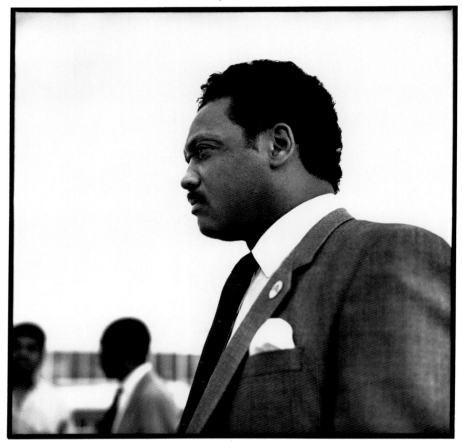

April 23, 1987 Austin, Texas

In the years between his first campaign and his second, his role in the politics of America had dramatically changed. Once a rank outsider, he had moved rather smoothly to a place inside his party, largely accepted if not always warmly welcomed by its hierarchy. Moreover, where he had once been largely dependent on the support of black Americans to sustain his pursuit, he had managed to construct a genuine rainbow coalition. It was a remarkable transition that, from time to time, seemed to surprise even him. There was very little change, if any at all, in the marvelous electricity of his public performances—and they always had that—inspired, perhaps, but practiced as well. He seemed less frivolous in 1988 than in his previous incarnation, less inclined to deal casually with serious matters, more willing to consider the long-term impact of what he was saying or doing. Yet, there was still an improvisational magic to his presence, a chemical charisma in the connection he made with his audiences—the sparkle in his eyes with or without the television lights, the earnest eagerness in his voice, the overwhelming inner dignity of one man spreading outward, lending that dignity to others.

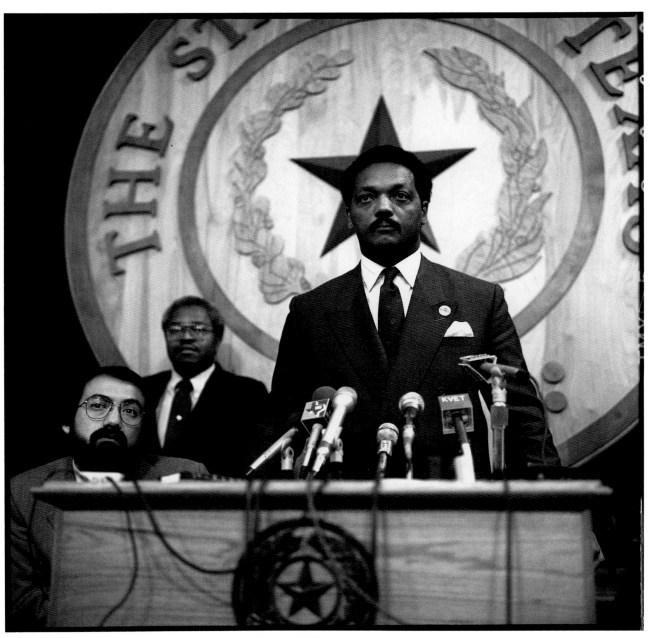

April 22, 1987 Austin, Texas

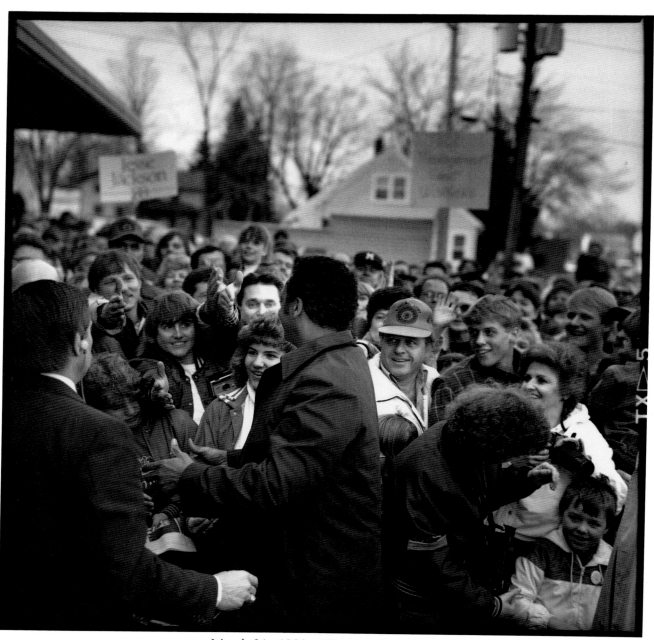

March 31, 1988 Wausau, Wisconsin

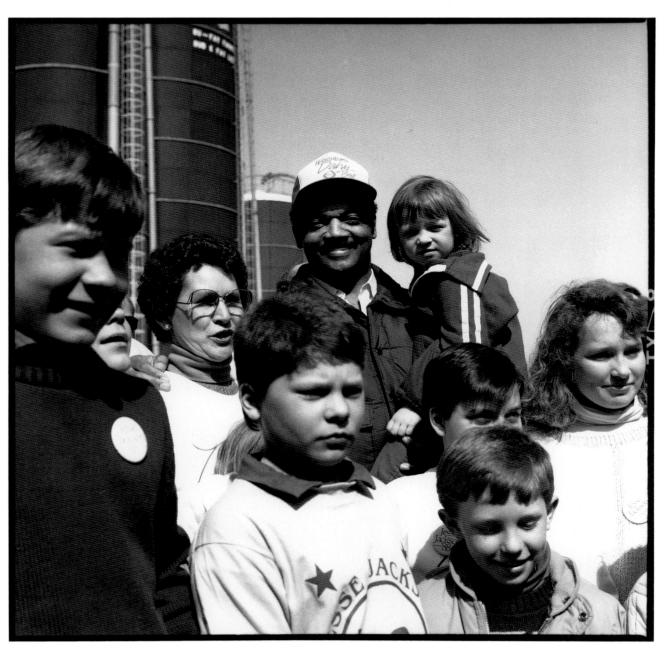

April 1, 1988 Amery, Wisconsin

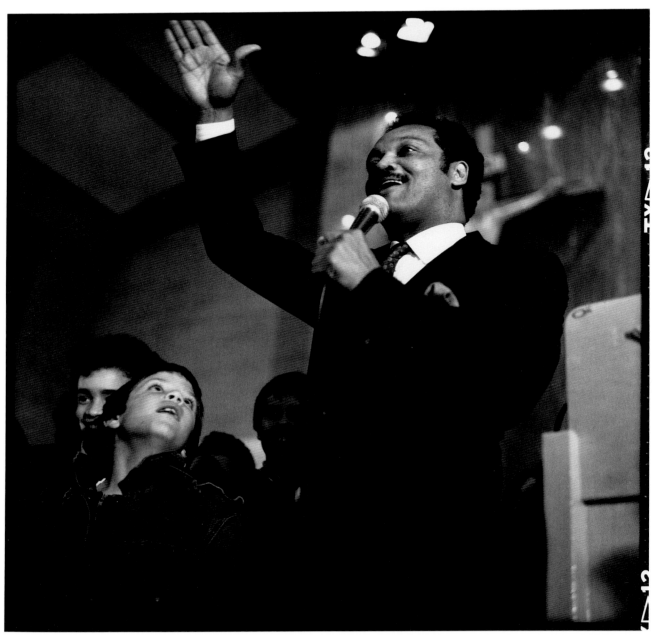

March 30, 1988 Milwaukee, Wisconsin

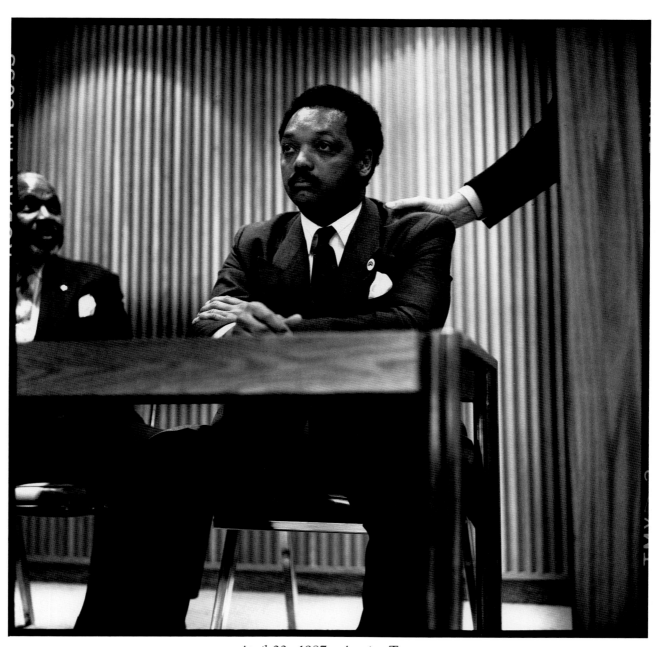

April 22, 1987 Austin, Texas

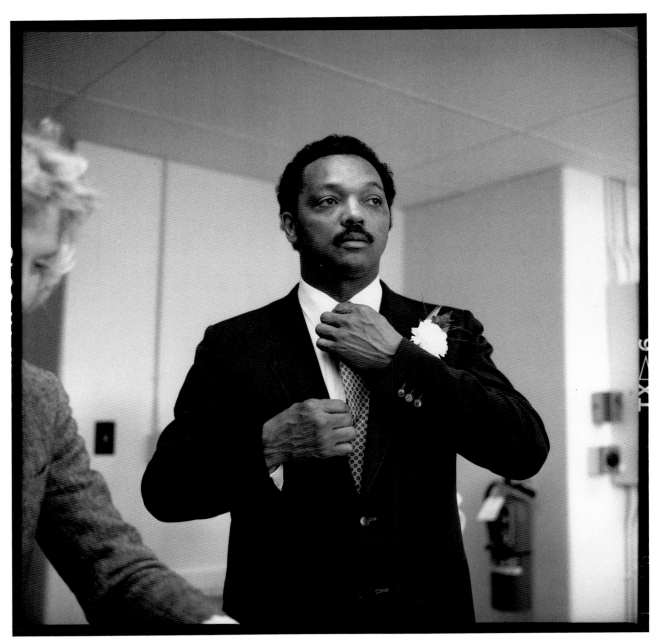

March 31, 1988 Sheboygan, Wisconsin

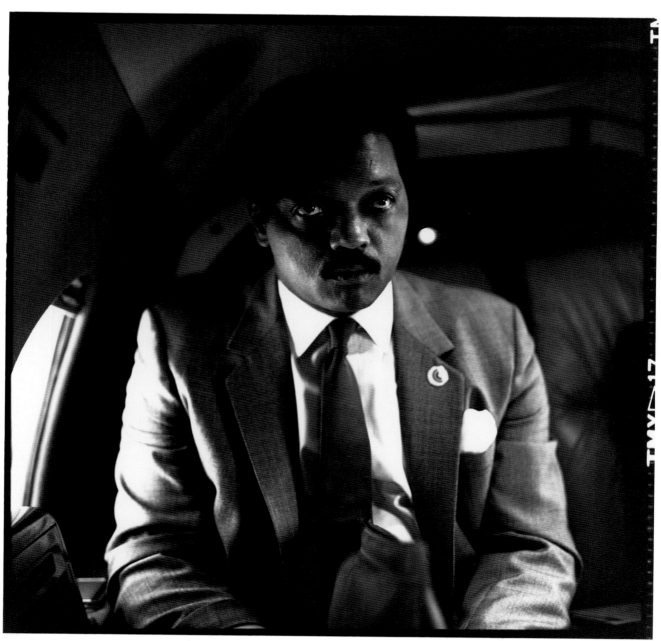

April 23, 1987 Airborne: Austin, Texas—Dallas, Texas

LLOYD BENTSEN

Selected July 12, 1988 Campaign ended November 8, 1988

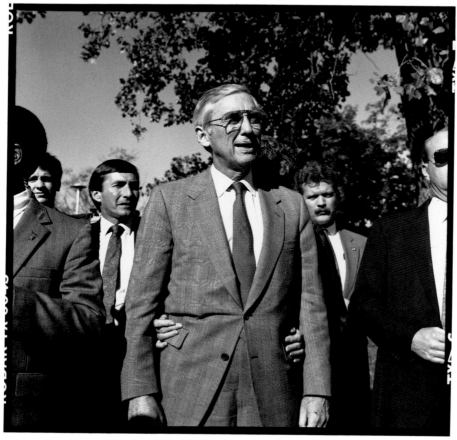

October 12, 1988 Fayetteville, Arkansas

There was a certain, unmistakable virility about him, despite his age. He had been strikingly handsome in his salad days and, with sufficient funds and privilege to soften the process, he had weathered the years rather gracefully. He carried himself like a man accustomed to power, perhaps like a president. Indeed, there was a sizable bloc of public opinion that would have preferred him at the top of the Democratic ticket rather than in its second spot. Nevertheless, he was not precisely a charismatic figure out on America's hustings. His mellifluous Texas twang was authoritative but not electrifying; he was constantly caught on the long horns of the record he had built over the years of his career in the Senate and the contradistinctive positions favored by his running-mate. It was an odd coupling at best, and it generated—for him, at least—an uncomfortable candidacy. That he carried it off with such apparent ease was a reflection of his sizable self-confidence, his realistic sense of who he was and what he was not. In that large congregation of candidates for whom 1988 was a losing year, he emerged with fewer scars and less baggage than most.

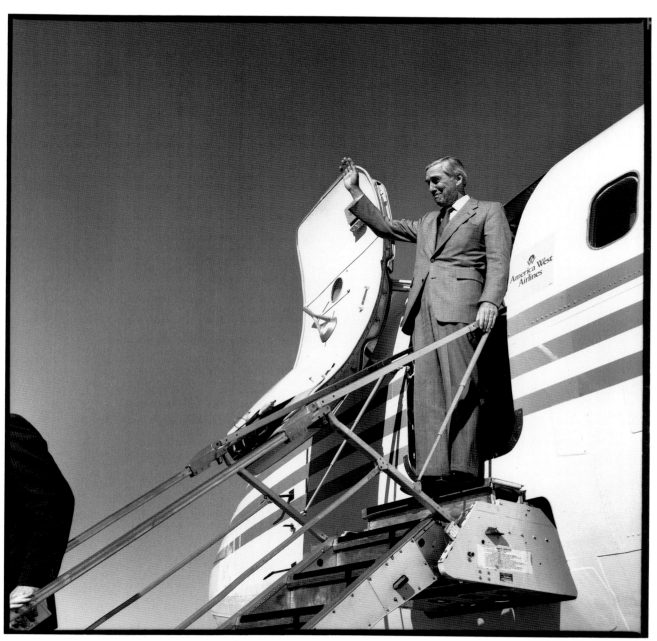

October 12, 1988 Fayetteville, Arkansas

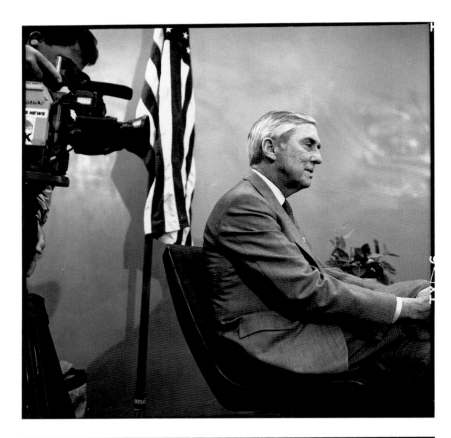

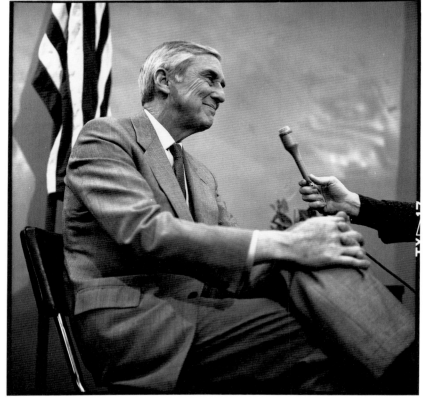

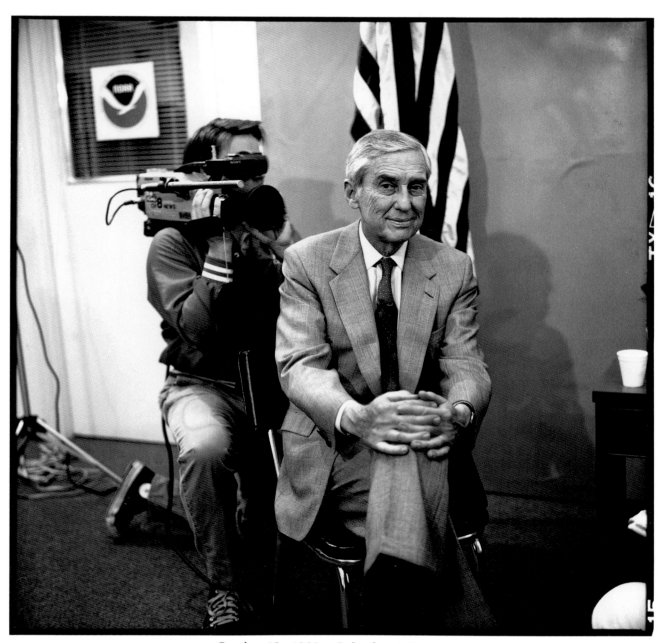

October 12, 1988 Columbia, Missouri

DAN QUAYLE

Selected August 16, 1988 Campaign ended November 8, 1988

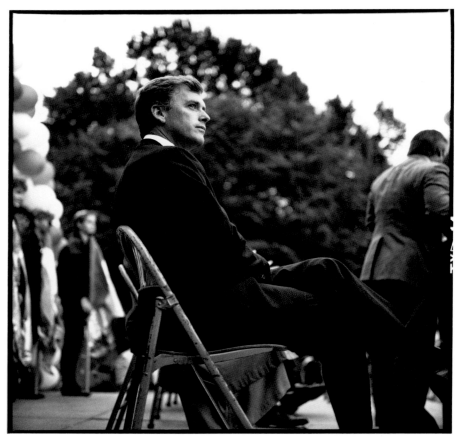

October 7, 1988 Raleigh, North Carolina

When his name had surfaced in those pre-convention lists of possible vice-presidential choices, it was virtually ignored by everyone, judged to be such an altogether unlikely choice and so patently illogical as to require no serious attention. When he was introduced on the banks of the Mississippi River, most of the Republican faithful in the crowd had absolutely no idea who he was. When he was finally identified, the principle public question was whether he more resembled Robert Redford or Pat Sajak—but when the details of his background suddenly began to make its way onto the front-pages and the network broadcasts, the image that seemed most appropriate for him was that of a deer caught in the headlights of an approaching car. He seemed utterly incapable of saying what it was he wished to say, often producing pure gobbledygook, such as his memorable declaration that there is nothing that a good defense cannot beat a better offense. He was shunted off the main pathways of the campaign into high school gymnasiums and the like. For a while, his running-mate offered a spirited defense of him. After that, his presence in the campaign was acknowledged as infrequently as possible.

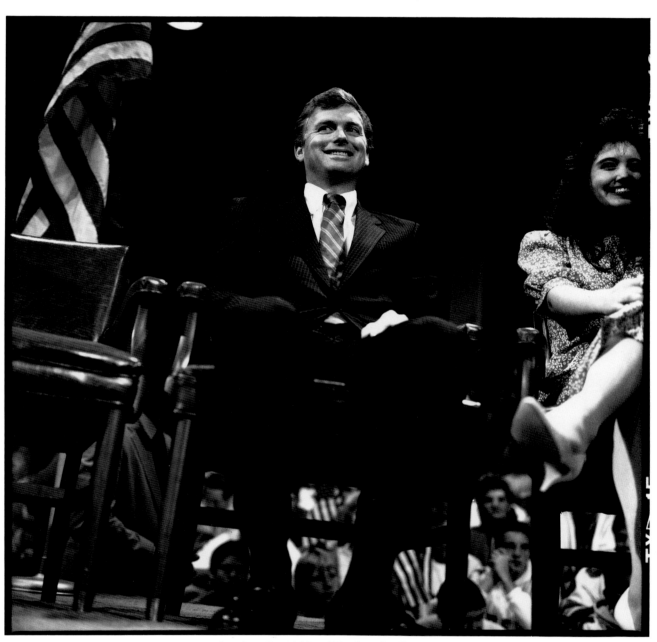

October 7, 1988 Woodstock, Georgia

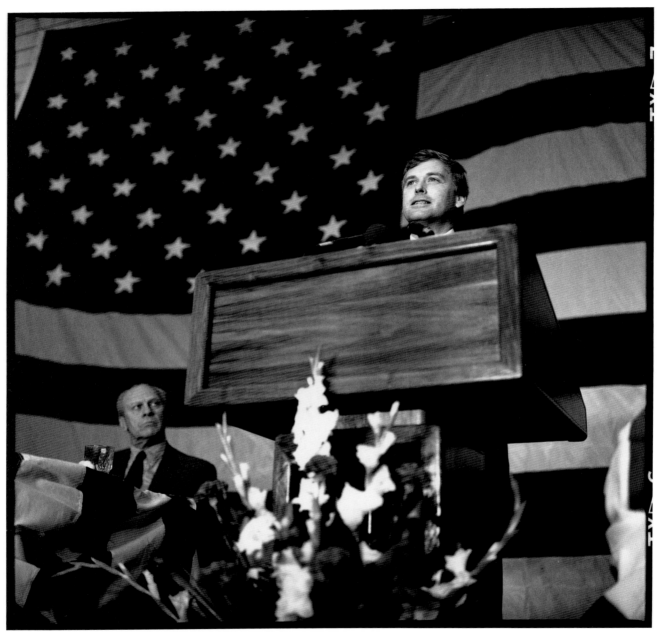

October 6, 1988 Springfield, Missouri

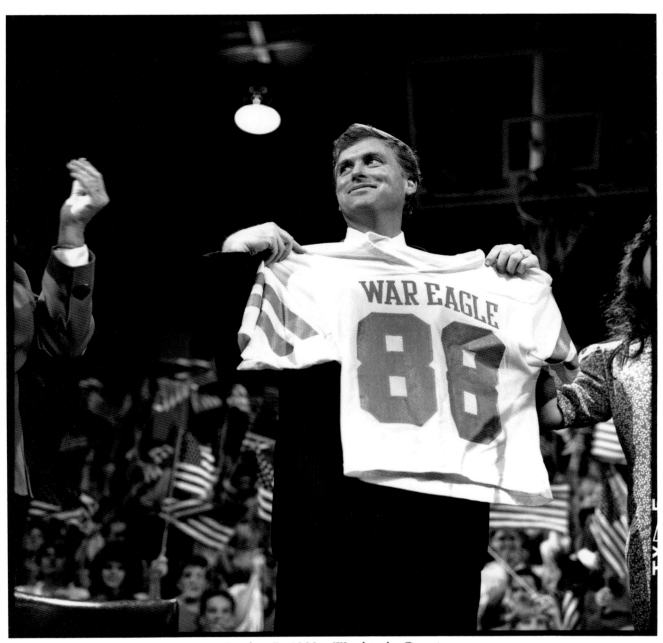

October 7, 1988 Woodstock, Georgia

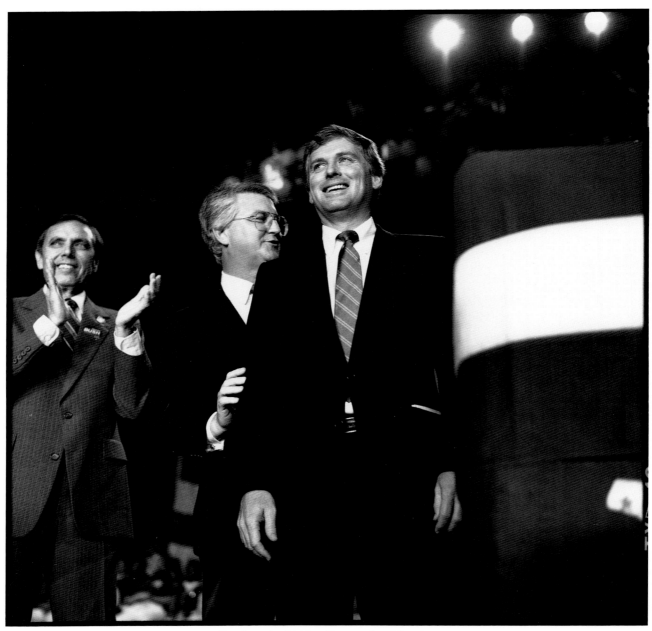

October 6, 1988 Pensacola, Florida

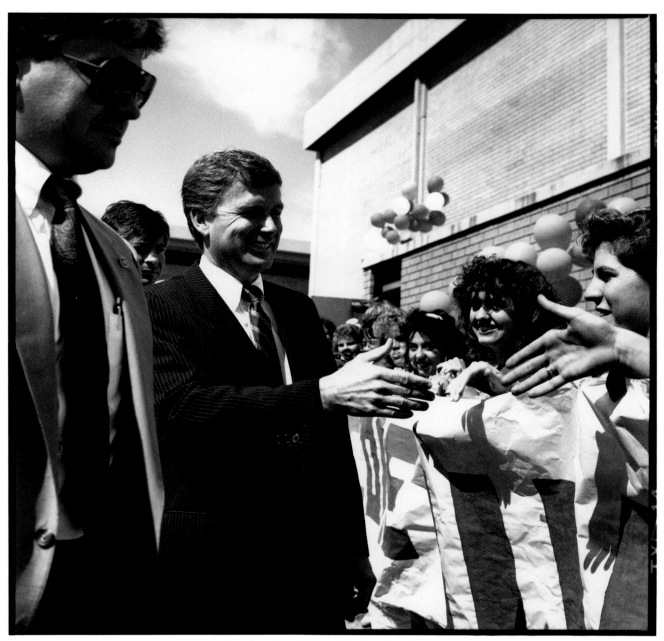

October 6, 1988 Woodstock, Georgia

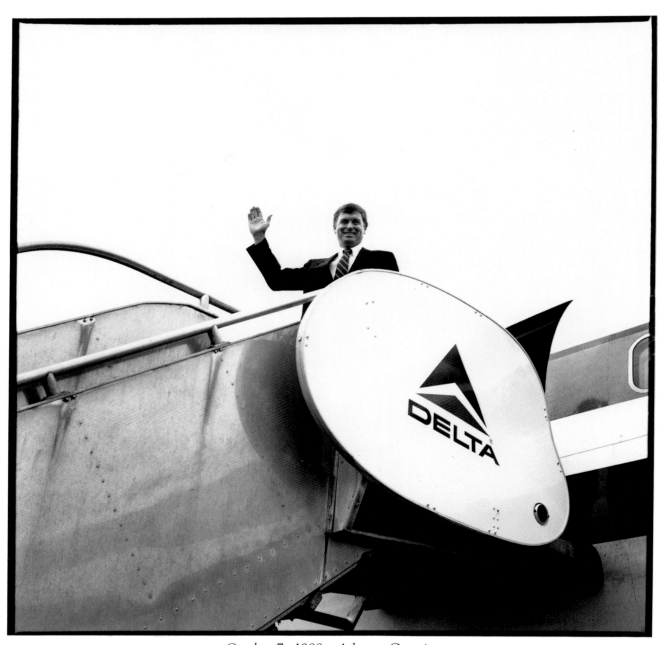

October 7, 1988 Atlanta, Georgia

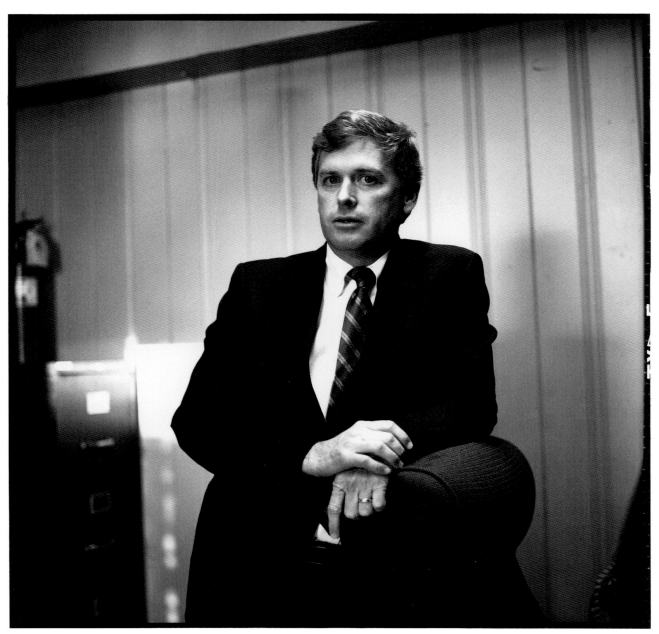

October 6, 1988 Pensacola, Florida

MICHAEL DUKAKIS

Entered race April 29, 1987 Campaign ended November 8, 1988

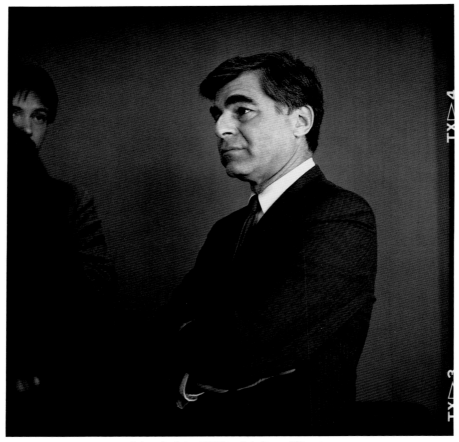

March 14, 1988 Moline, Illinois

He seemed slightly condescending in his public rhetoric, as though he believed that, having once articulated his views on any given issue, there should be no need to reiterate. There were moments in his campaign, both before and after he became his party's nominee, when he seemed utterly bored by the whole affair, as though there were other items that required his dispassionate attention, something else that interested him more. That had always been the understated approach that had worked for him. He had enjoyed a successful and satisfying public career in his home state, had become adept at dealing with the provincial peculiarities of its politics, had even translated a traumatic defeat into consecutive victories—but for the most part, his critics had always been to his left, since he was not really a liberal. He had learned to handle fire from that direction and return it. The attack from the right—on his patriotism, on his sensitivity to crime and punishment—caught him off balance. The assault on how he looked, how he spoke, even down to his size and so-called lack of passion, was completely discombobulating. In the mean streets of 1988, at least, he was way out of his league.

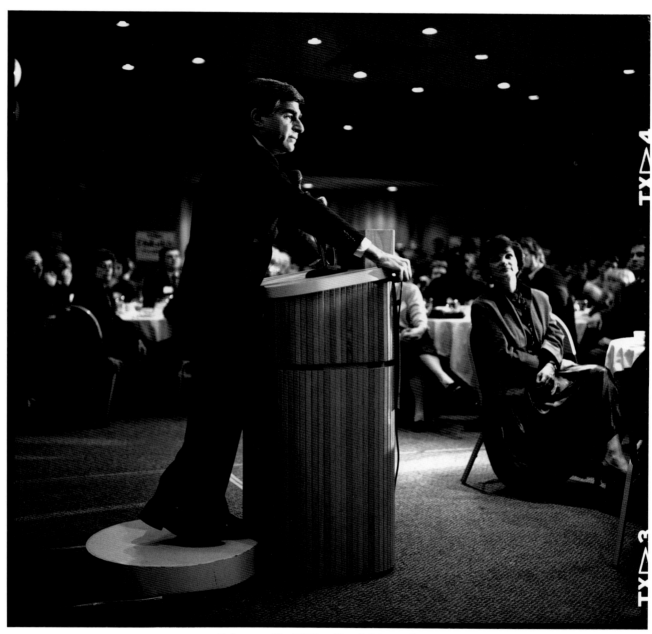

February 7, 1988 Des Moines, Iowa

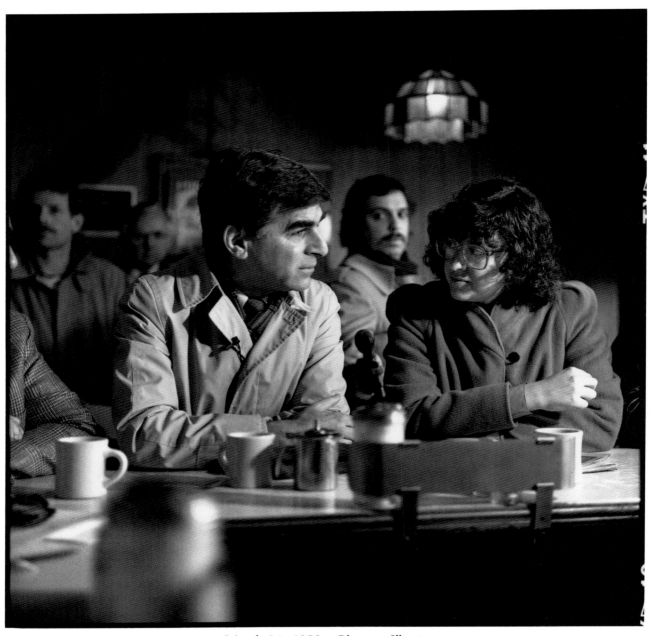

March 14, 1988 Chicago, Illinois

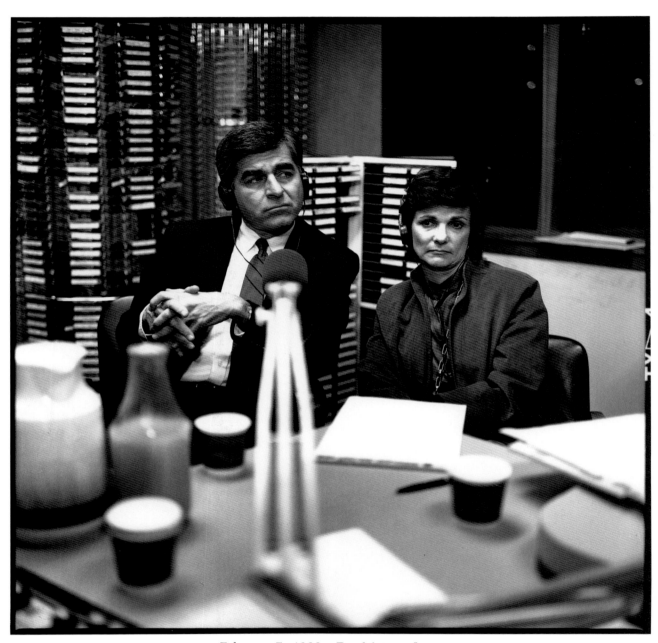

February 7, 1988 Des Moines, Iowa

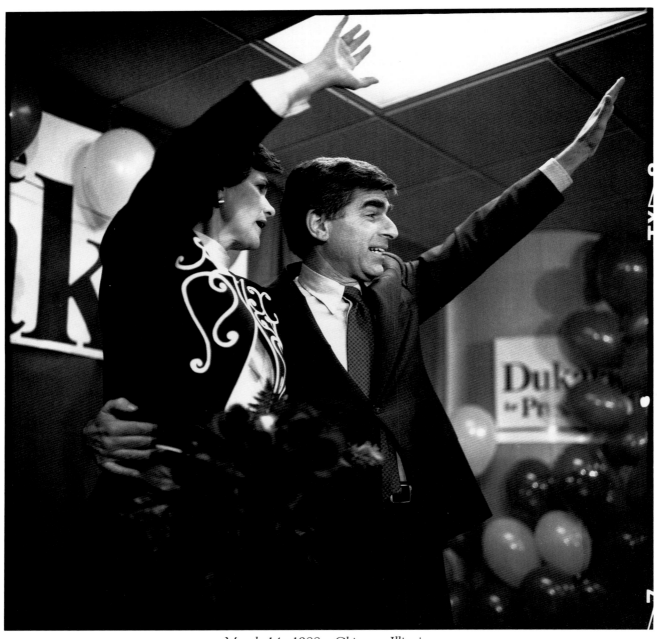

March 14, 1988 Chicago, Illinois

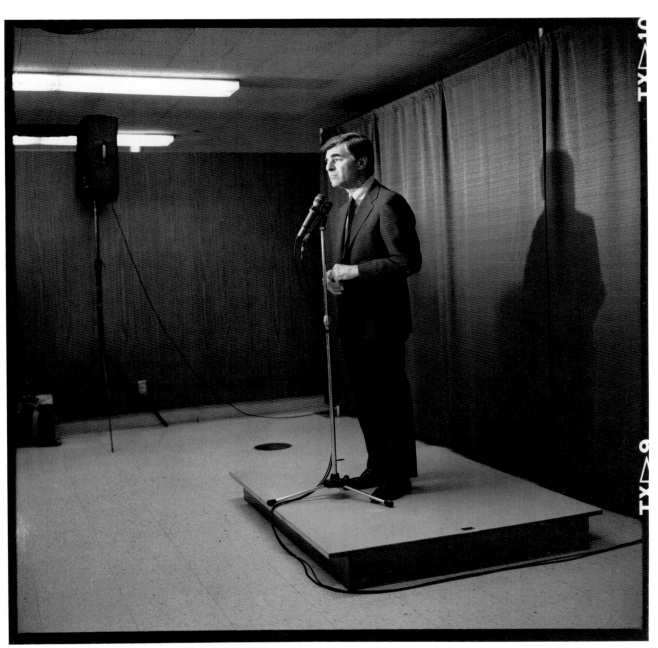

March 14, 1988 Springfield, Illinois

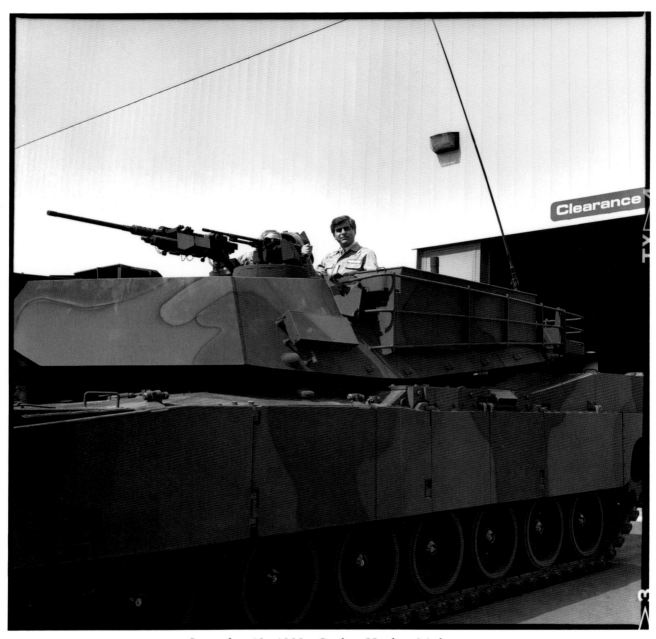

September 13, 1988 Sterling Heights, Michigan

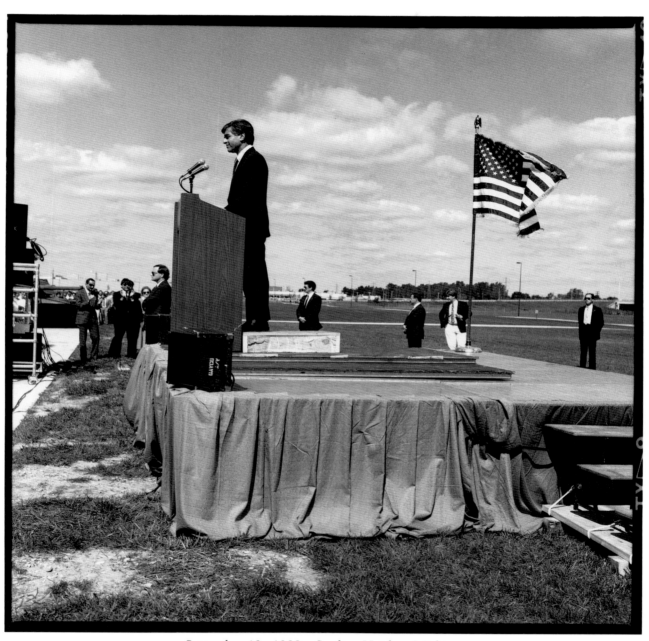

September 13, 1988 Sterling Heights, Michigan

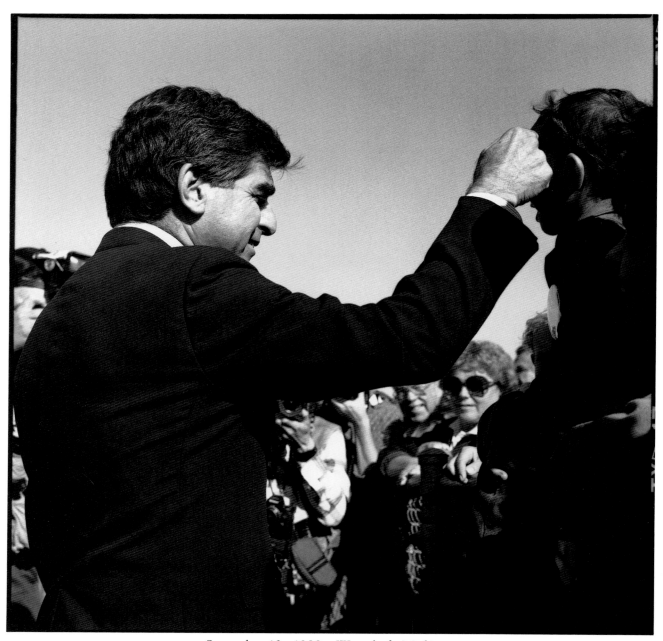

September 13, 1988 Waterford, Michigan

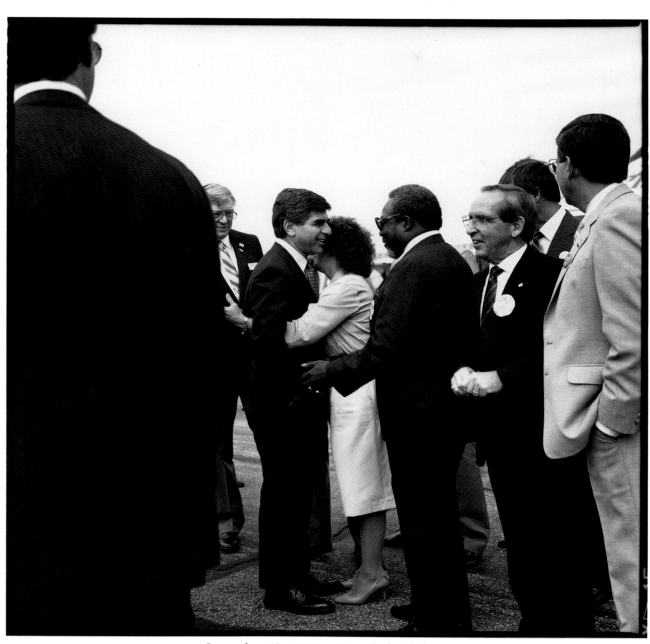

September 13, 1988 Waterford, Michigan

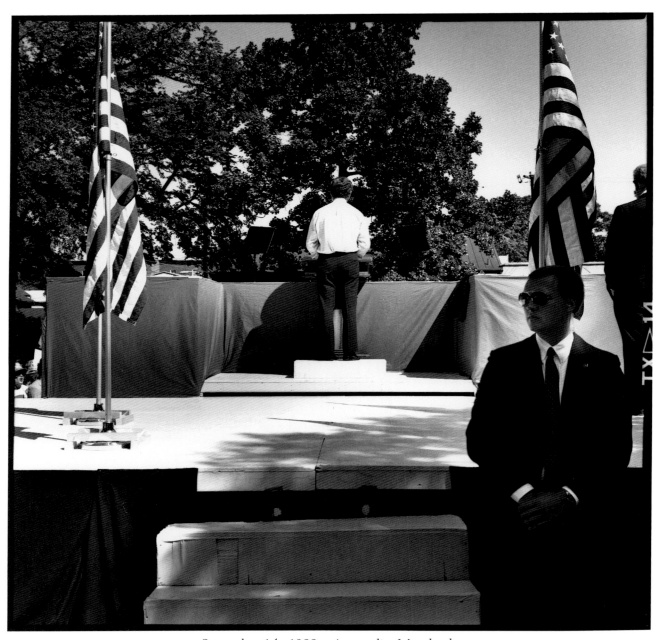

September 14, 1988 Annapolis, Maryland

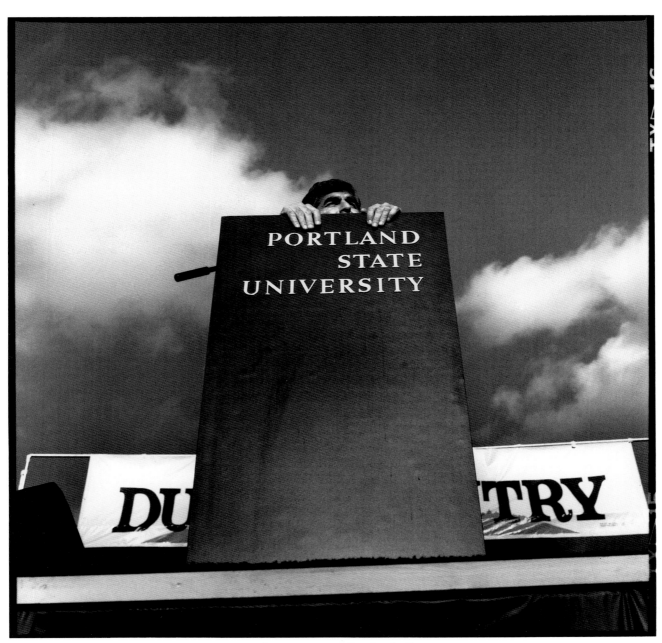

November 6, 1988 Portland, Oregon

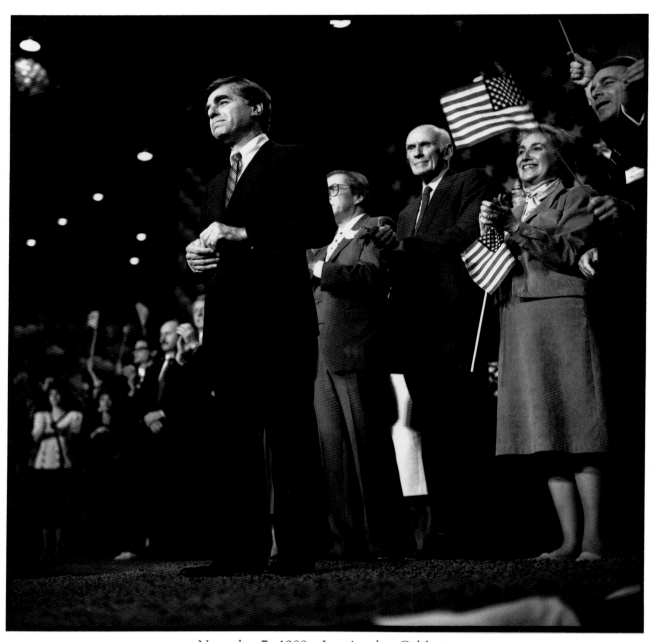

November 7, 1988 Los Angeles, California

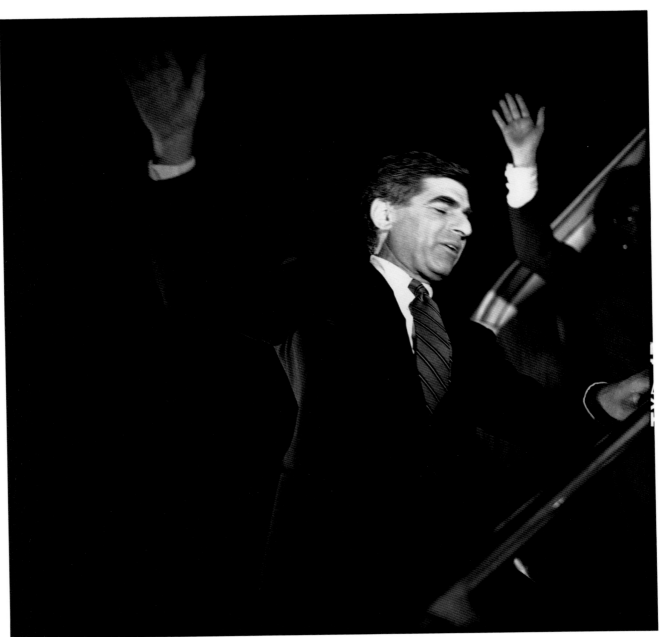

November 7, 1988 Los Angeles, California

GEORGE BUSH

Entered race October 12, 1987 Campaign ended November 8, 1988

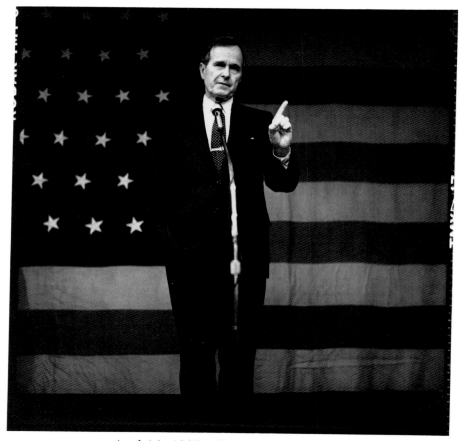

April 16, 1987 Keene, New Hampshire

A fairly gifted athlete in his youth, he had become a noticeably awkward man in public, his hands and arms urgently intersecting themselves at all sorts of peculiar angles, uncoordinated to his words, useless or even counter-productive as communicative gestures. Then, almost overnight, all that seemed to disappear. His media managers counseled him that less would always be more and advised him to stay more in control, reduce the size of his speaking space, and remember the dimensions of the television screen, the limits of the camera's frame—and he learned and, to his credit, he changed. He even lowered his voice from the nasal, twangy whine that had been his trademark for years—and the initial source, perhaps, of his image as a wimp—to something a little more authoritative. But even as he lowered its pitch, he raised its volume in his unrelenting attack on his opponent. As public opinion shifted dramatically in his favor, his whole demeanor also changed, including his physical posture. He stood a little straighter, moved with a bit more grace. It was as though he'd shed an entire persona and replaced it with one more suited to his success.

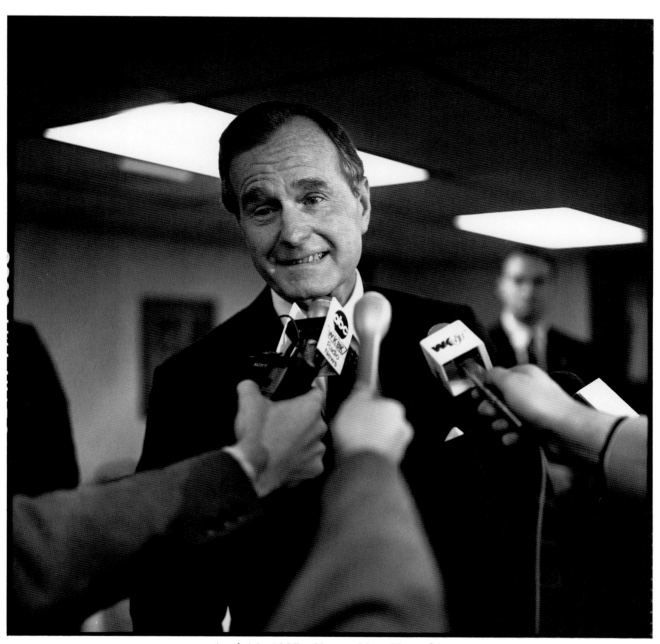

April 16, 1987 Keene, New Hampshire

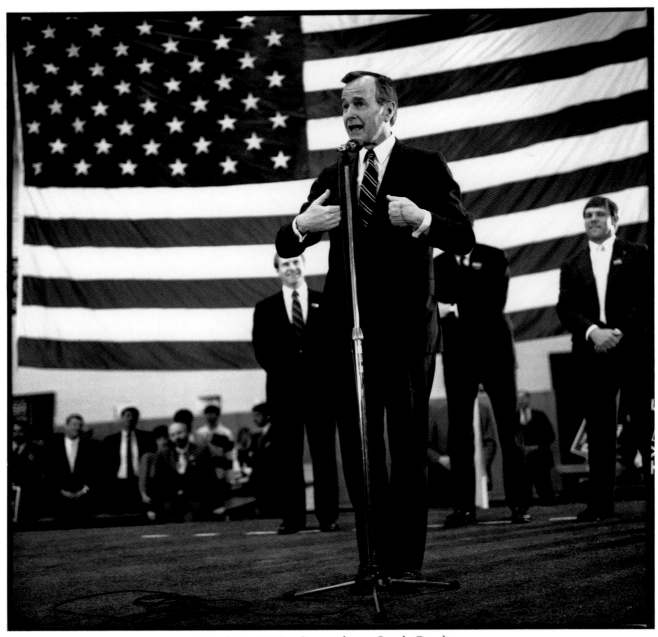

March 3, 1988 Spartanburg, South Carolina

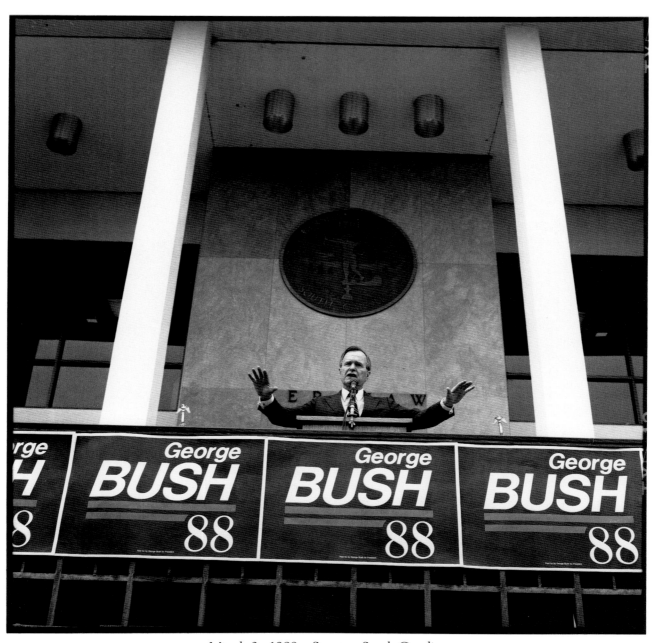

March 3, 1988 Sumter, South Carolina

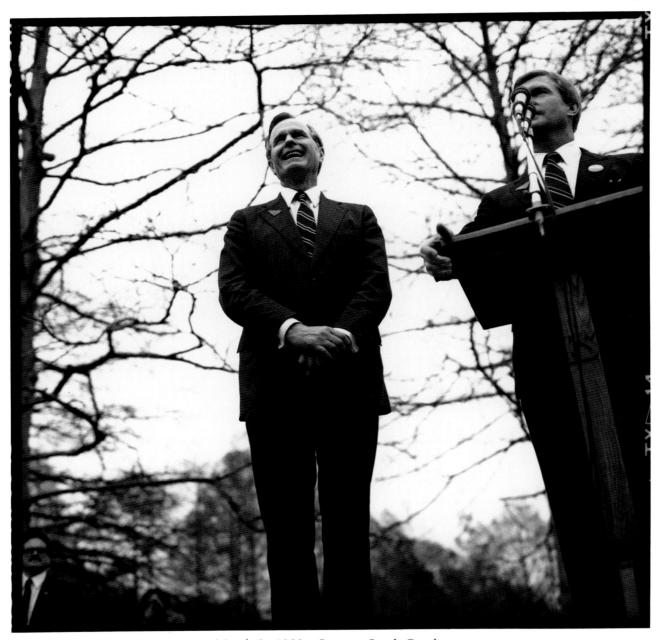

March 3, 1988 Sumter, South Carolina

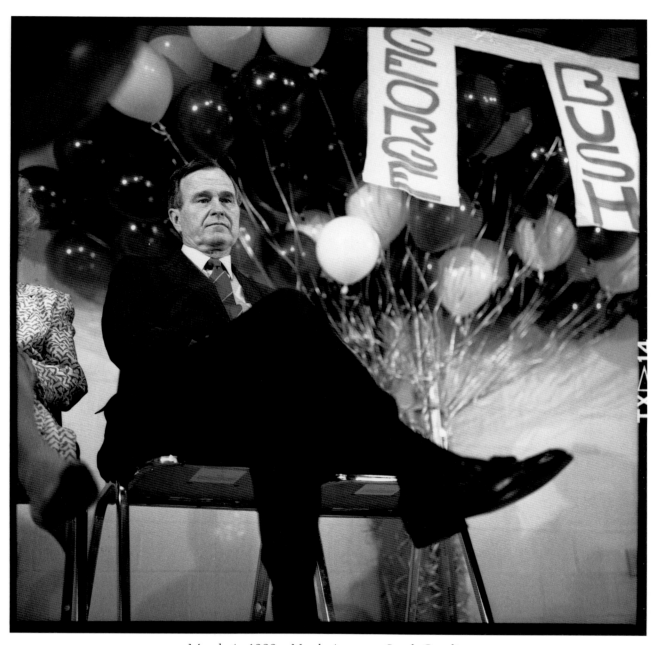

March 4, 1988 North Augusta, South Carolina

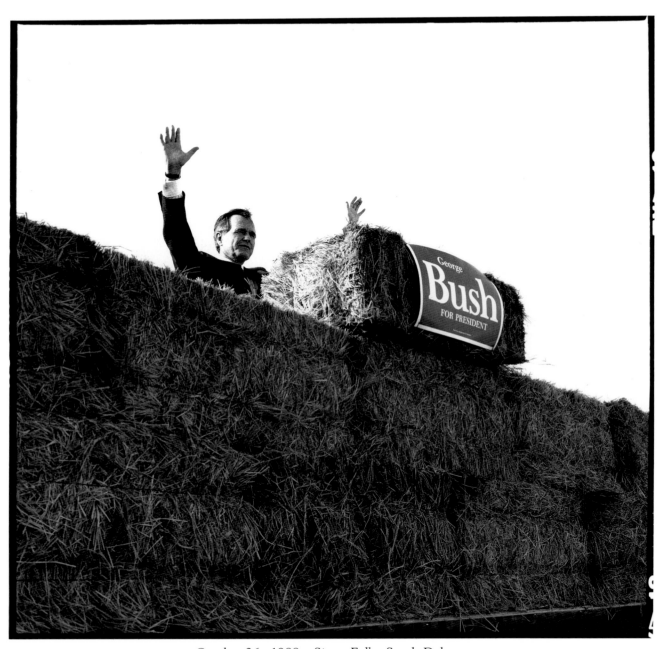

October 26, 1988 Sioux Falls, South Dakota

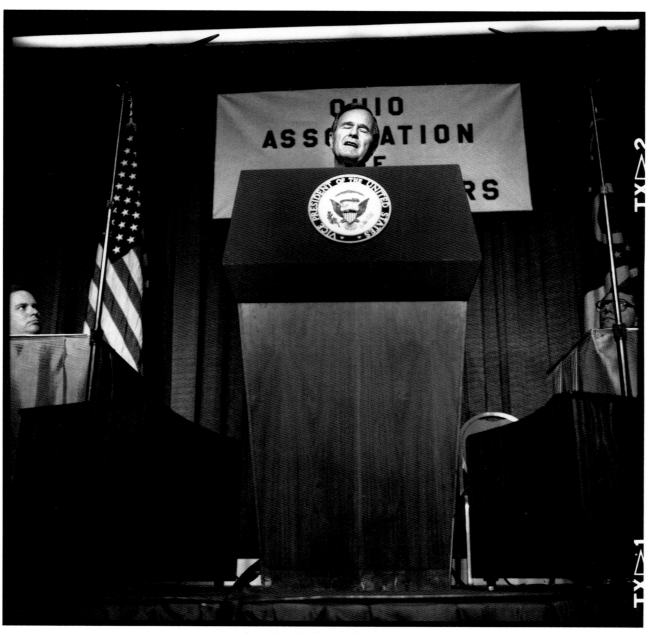

October 25, 1988 Columbus, Ohio

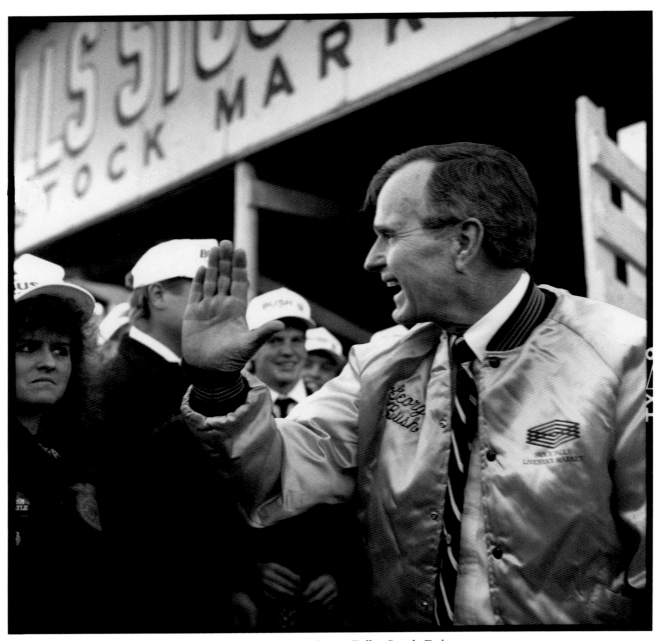

October 26, 1988 Sioux Falls, South Dakota

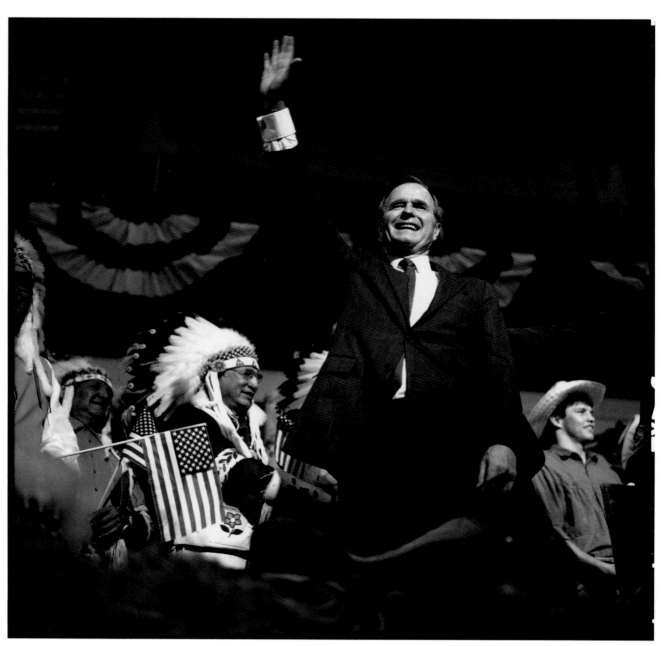

October 26, 1988 Billings, Montana

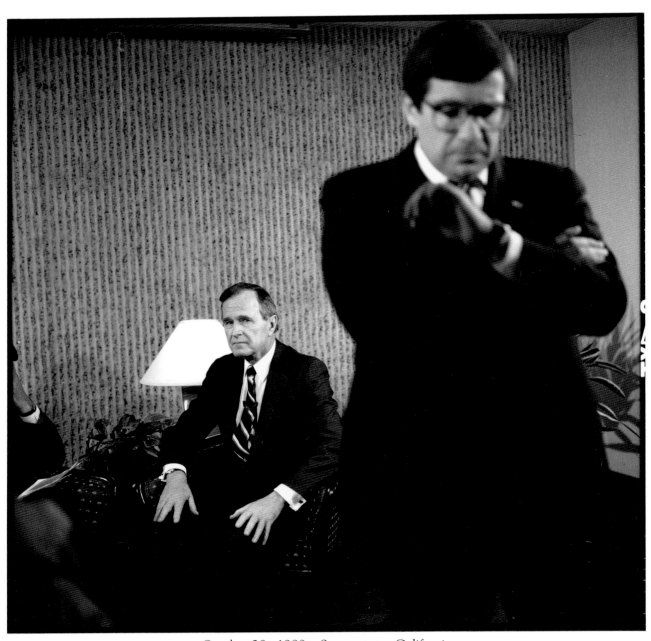

October 28, 1988 Sacramento, California

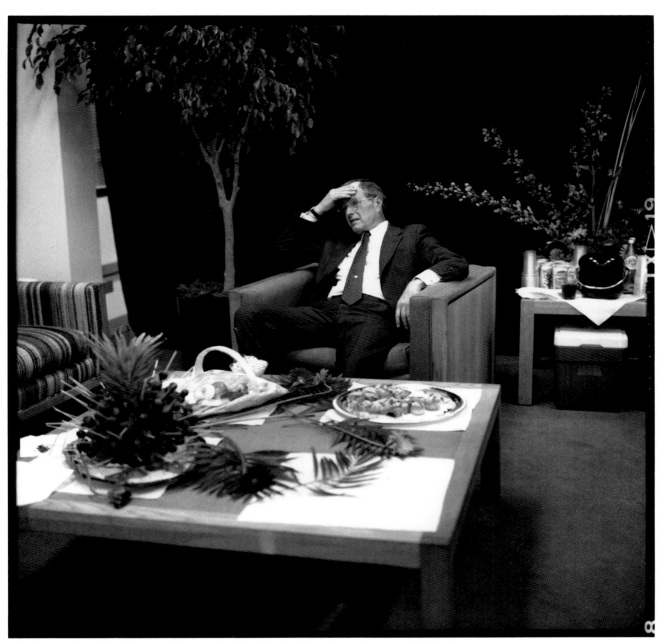

October 27, 1988 Santa Clara, California

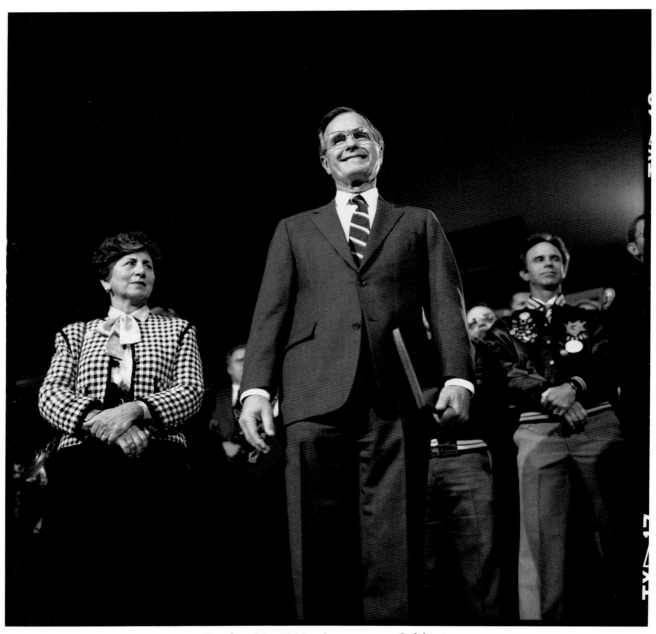

October 28, 1988 Sacramento, California

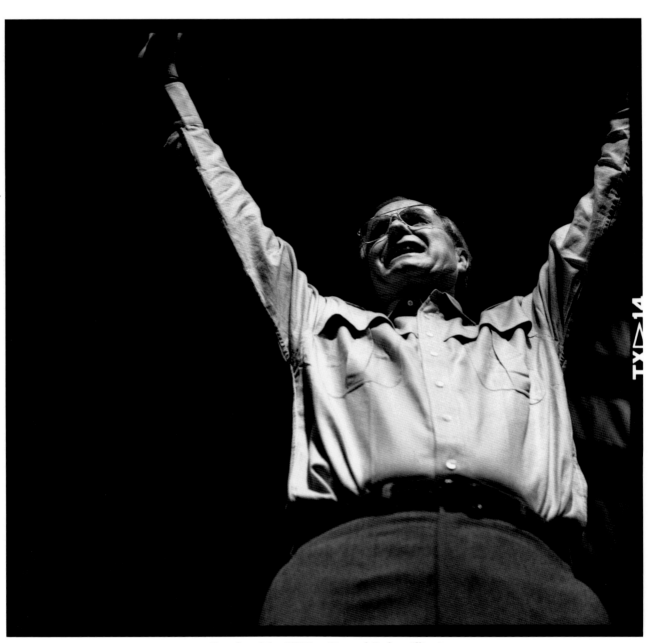

October 29, 1988 Crystal Lake, Illinois

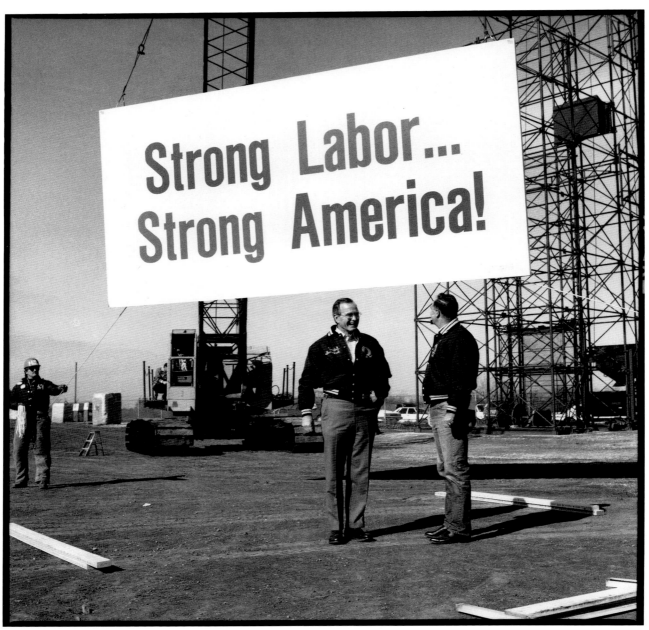

October 29, 1988 Plainfield, Illinois

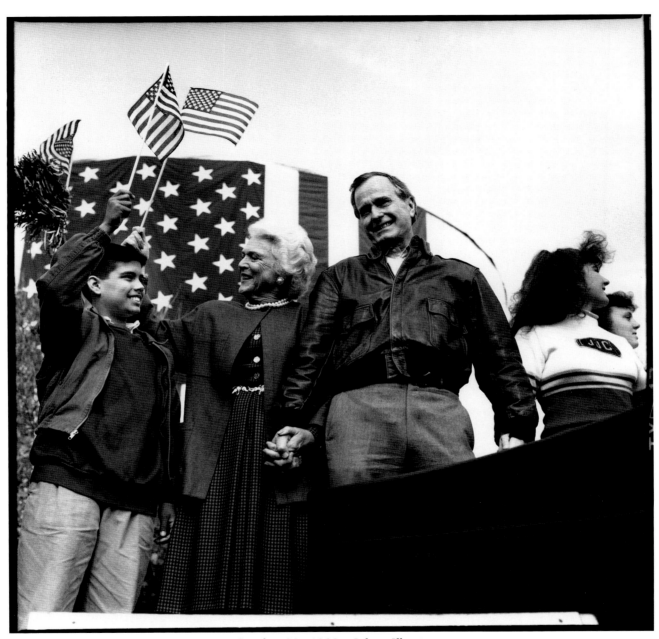

October 29, 1988 Joliet, Illinois

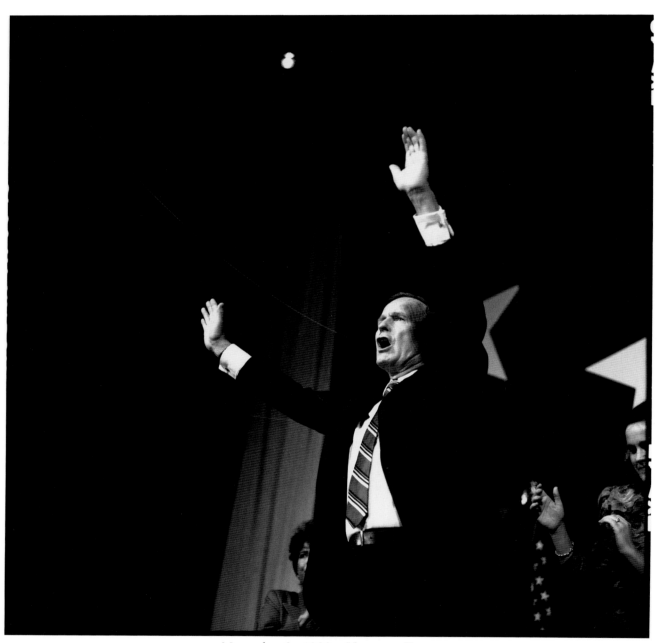

November 8, 1988 Houston, Texas

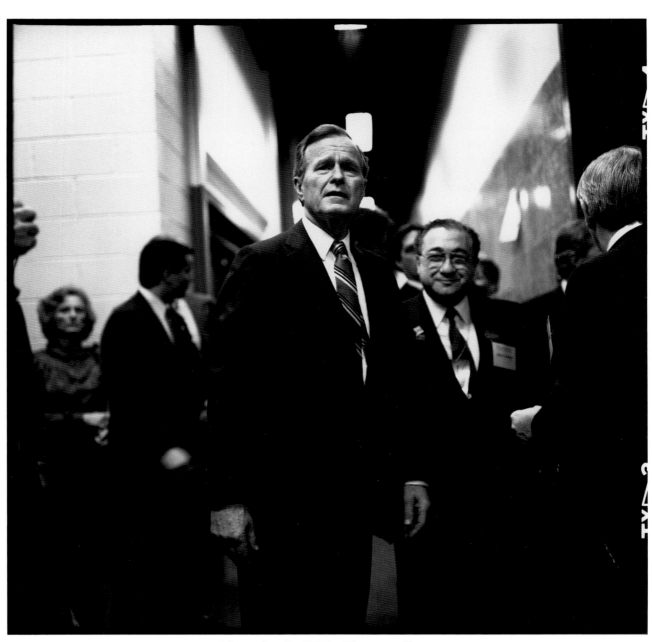

November 8, 1988 Houston, Texas

AFTERWORD

by JANE LIVINGSTON
Associate Director and Chief Curator
of The Corcoran Gallery of Art,
Washington, D.C.

American photojournalism has undergone profound changes in the last decade, gradually embracing color almost to the exclusion of black and white work. But what is not so much noticed in successful magazine work is a characteristic that has to do with much more than the simple use of color film. Gradually, beginning at some point in the late-1970s, magazine editors, and, one assumes, the public, began to look for pictures that were chromatically high-pitched, evenly lit, and often oddly shadowless. The subtlety and mystery, and often the gritty immediacy, of much of the black and white photography dominant in the 1960s and 1970s gave way in the print media to an increasingly artificial, often strident quality. Much of this recent color work has been created by individually proud and masterful artisans, with ever more sophisticated film and lighting technology and more powerful and flexible printing capabilities. Nevertheless, it often lacks the character and intimacy of personal journalism.

We have become accustomed, both in television and print, to seeing vivid, "accurate," highly saturated color imaging; we assume this represents a gain in veracity and aesthetics alike. But what we are actually seeing is the result of a medium in which technique has begun to get in the way of the spontaneous connection between photographer and subject. This new color photography often requires elaborate lighting setups, assistants, and a wide array of camera equipment.

One American photojournalist who has shown himself to be as good as the best in this smooth and increasingly automated medium of 35-mm color work is Arthur Grace. Grace has worked long enough and widely enough on assignment with American politics—and many international stories—to thoroughly understand the job. But he had added another dimension to what he has so assiduously learned in the last 15 years working for UPI, *The New York Times, Time,* and now *Newsweek.* He now brings a new depth of attention to his subject, using those attributes of patience and careful thoughtfulness in the photographer's approach that the high-speed, disposable journalism of recent times has so often undervalued.

A paradox lies at the heart of this shift of concern Grace brought to the Democratic and Republican Presidential campaigns of 1988. He determined to shoot this long, complex event leading up to November 1988 exclusively in black and white and using only available light. His sole camera was a twin lens 2¼ Rolleiflex loaded with medium-format 120 film. It was a decision to slow down both literally and conceptually. Yet the reality of the pictures he produced with this technique is somehow more instantaneous than seems true of the motor-driven, auto-flash 35-mm technique.

Working with a Rolleiflex, several things come into play that most contemporary photojournalists do not even consider. First, the photographer is looking down into the viewfinder, rather than through it as through a window or peep-hole. Second, there is no interchangeability of lenses; the Rolleiflex has a fixed 80-mm "normal" lens. Third, the film is hand-advanced and has only twelve frames on a roll. Thus, there is a natural tendency to take great care with each shot, to wait, to hunt for the successful moment. The result is a kind of candor and true historical veracity that one rarely sees today in political photography. Grace's subjects are being presented not necessarily as they would want to be seen—but as they are.

Grace followed some fifteen campaigns, from February 1987 to November 1988, managing to be near each candidate at certain symbolic public events and sometimes at the more revealing private scenes taking place around the edges. It is often these casual, introverted, or unguarded moments in the lives of his subjects that speak most eloquently about the nature of the men depicted. Many of these portraits seem to penetrate beneath the surface of their subjects' self-presentation;

Grace managed to be near each candidate . . . sometimes at private scenes taking place around the edges.

what they reveal is occasionally strikingly contradictory to the general way in which the public perceives them. For example, it might be that the most resonant picture of the feisty and sophisticated Senator Robert Dole is the one catching him in a moment of pensiveness, brow furrowed, chin resting on hand—an entirely reticent, quiescent portrait, one that somehow communicates something essential about the man.

Others of Grace's pictures in this series capture the spirit of their subject not so much from personal expressiveness as from the photographer's shooting of his subjects in various settings, letting both the background and the body language convey the psychological truth of the picture. Senator Albert Gore seated by himself in a television studio, miked and wired and staring impassively into some undefined world of difficult questions; Pat Robertson, surrounded by members of the press, waving and smiling upward to the photographer's lens; Al Haig awkwardly, woodenly, leaning both forward and back to shake hands with an anonymous citizen on some unidentified American pavement—all these images tell their stories as much through their settings and posturings as through facial language. Perhaps the most painfully revealing moment immortalized through Grace's lens depicts Governor Michael Dukakis standing

in a crowd, smiling, being embraced by a sincere admirer—with his hands firmly, stolidly buried in his pockets, his body rigid, erect.

Yet Grace is also able to move close to his subjects and to capture the most intimate revelations about character and temperament by employing the simple close-up. Both in his portraits of Jesse Jackson and George Bush, particularly, the full range of

March 3, 1988 Rock Hill, South Carolina

these individuals' styles and moods emerges as naturally as if there were no intermediary between the subjects and us who are viewing the pictures.

In Grace's camera eye, we begin to sense something of the experience itself of campaigning in America. If his vision is accurate, the excitement of making the run is tempered by tedium; the constant tension between presenting oneself positively and expressing oneself distinctively takes a toll on even the most experienced politicians. It is a fascinating and complex process, one a little more understandable through the document Arthur Grace has given us. ❧